KRIS HILTS

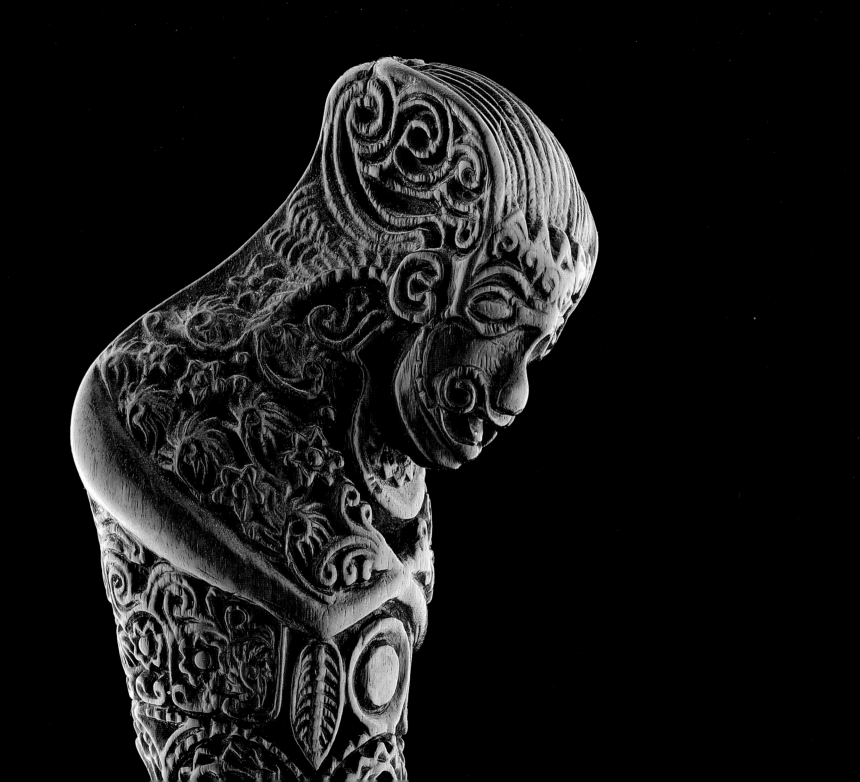

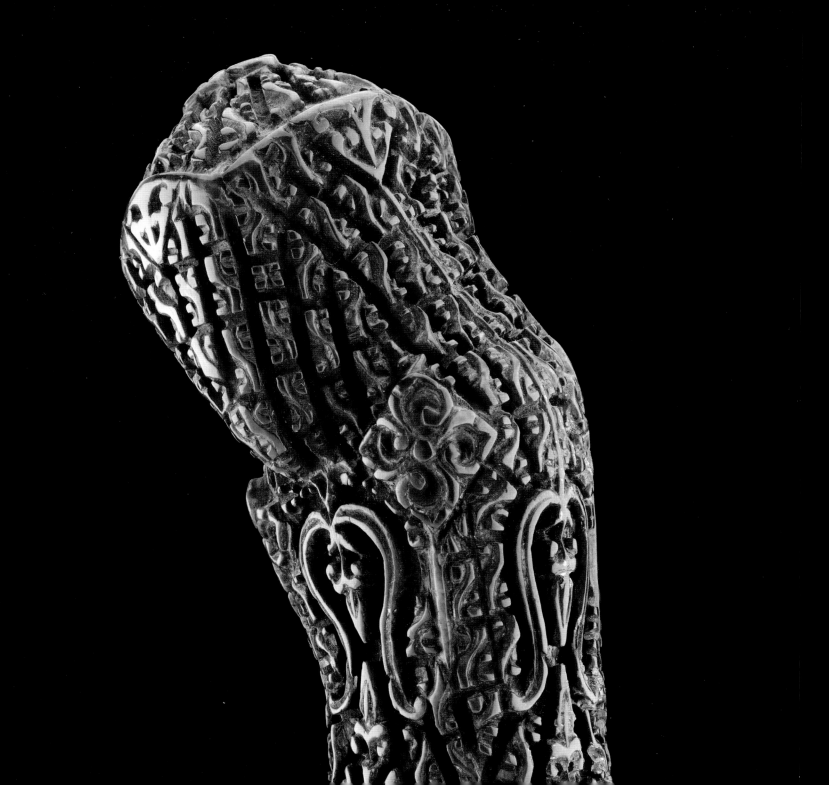

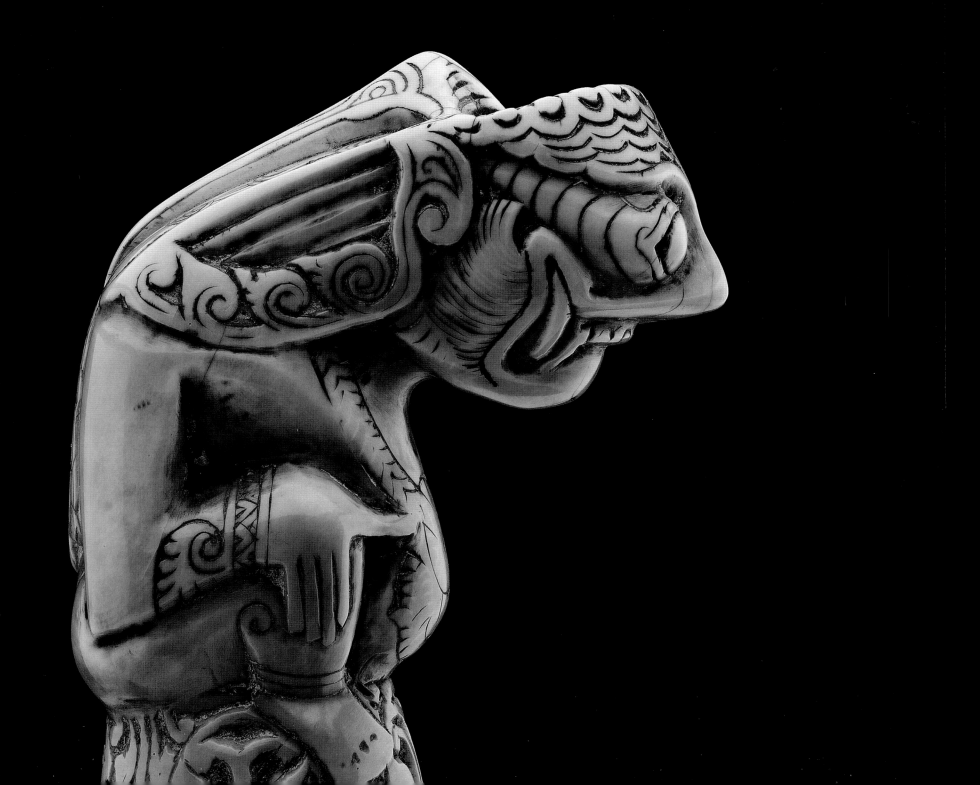

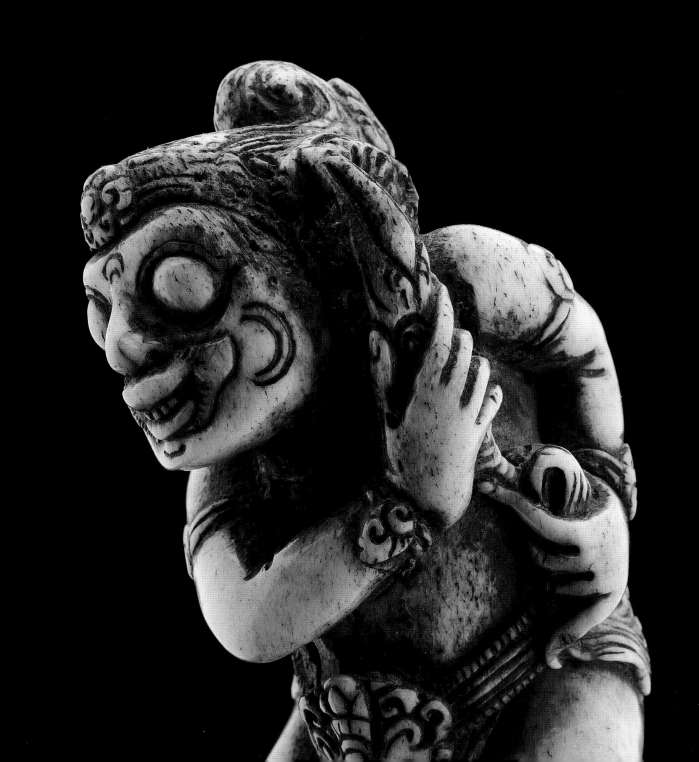

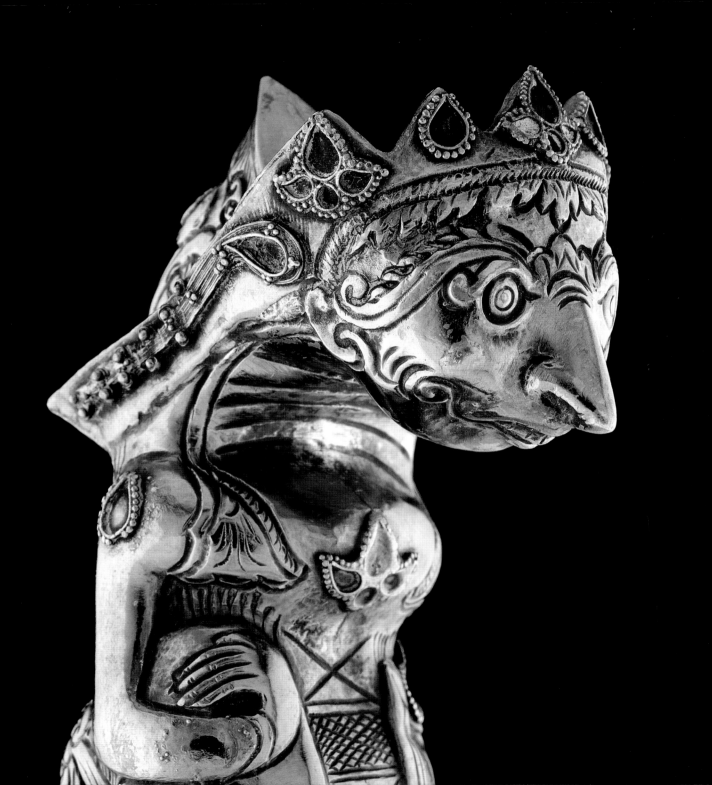

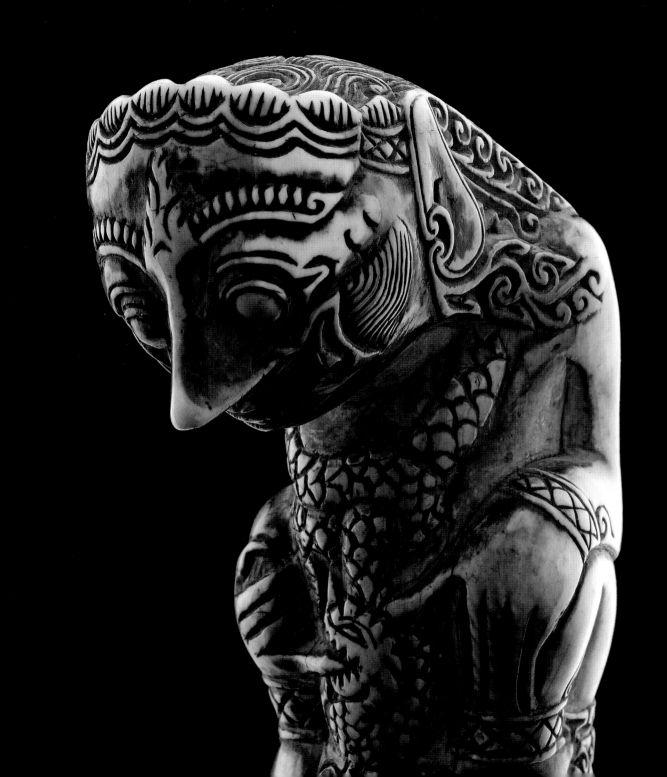

Vanna Ghiringhelli

KRIS HILTS

MASTERPIECES OF SOUTH-EAST ASIAN ART

photographs by Mauro Magliani and Barbara Piovan

Editorial Coordination
Laura Maggioni

Art Director
Annarita De Sanctis

Production Manager
Enzo Porcino

Translation
Julian Comoy

Editing
Andrew Ellis

Map
Giorgia Bianchi

ISBN 978-88-7439-585-9

5 Continents Editions
Piazza Caiazzo 1
20124 Milan, Italy
www.fivecontinentseditions.com

Distributed in the United States and Canada by Harry N. Abrams, Inc.,
New York. Distributed outside the United States and Canada,
excluding France and Italy, by Abrams & Chronicle Books Ltd UK,
London

CONTENTS

13 Kris Hilts: Masterpieces of South-East Asian Art

18 Map of Indonesia

22 Catalogue Entries

156 Bibliography

158 The Authors

159 Acknowledgments

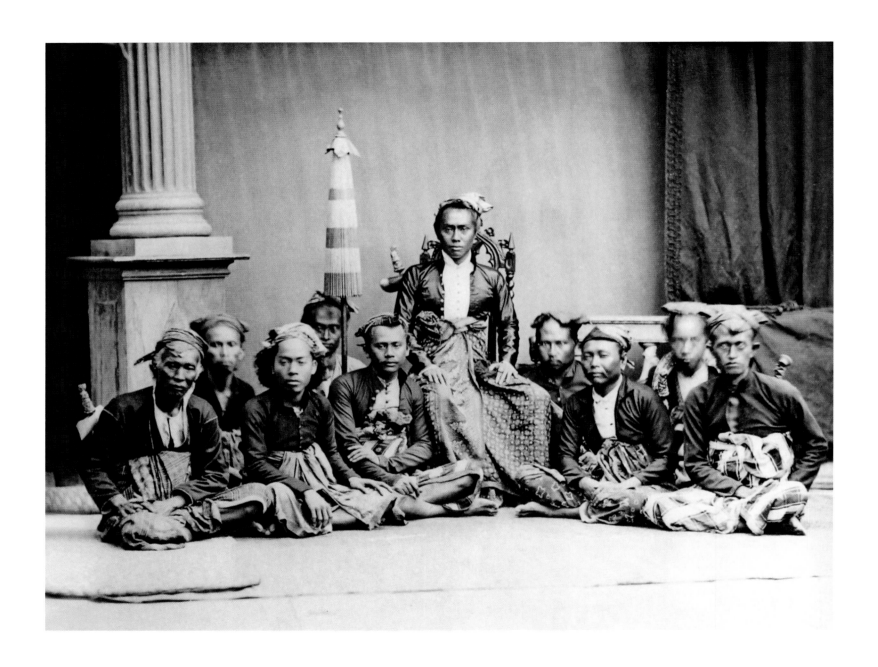

KRIS HILTS: MASTERPIECES OF SOUTH-EAST ASIAN ART

This book presents the Lanfranchi Collection of kris hilts, elements of the weapon which has become the emblem of the Indo-Malay Archipelago, and as such proclaimed a Masterpiece of the Oral and Intangible Heritage of Humanity by UNESCO in 2005. The pieces in the collection are displayed here in all their beauty, originality and mystery, with the purpose of drawing the attention of a wider public to these admirable works of art gathered with great taste and discrimination. These unique objects were created in the vast and extraordinary melting-pot of South-East Asia, where each area's local culture has blended with elements of Indian, Islamic, Chinese, and European culture.

Kris hilts are the fruit of this wonderful fusion, and the variety of shapes they exhibit and range of materials used in their manufacture conjure up the ancient atmosphere of the Archipelago, deep as the pulsing of its volcanoes, and offer an insight into its life and spirit. Falling under the spell of these shapes molded in coarse or precious materials, and peering between their folds, between the engraving and symbols, we find the legacies of Buddhism, Hinduism, and ancient ancestor cult, the influences of China and Islam, and above all else the allure of these Indo-Malay islands, and the seas over which they are scattered. These exquisite objects tell of the history, social status, wealth, poverty, good and ill luck, magical powers, traditions and religious life of the Archipelago's inhabitants.

These wonderfully carved, chased, or engraved objects can certainly be considered artistic masterpieces, and the details in their abstract, zoomorphic or anthropomorphic forms provide clues to precisely where each individual kris hilt was manufactured.

The hilt is fitted onto an intricately worked cup-shaped metal element frequently studded with precious stones or colored glass. It is fixed to the tang (the fine extension of the blade itself) by means of a small piece of twisted cloth, sometimes replaced by human hair owing to the spiritual and mystical power it embodies.

In addition to being a skilled carver, engraver, chaser, and embosser, and to having a highly-developed sense of beauty, the artist-craftsman who creates this object must also be thoroughly familiar with the tradition, symbolism and magical properties of the materials used in fashioning the hilt. Nothing is left to chance, and every material is chosen for a specific purpose: ivory drives away enemies, while ivory derived from the fossilized molar of an elephant or from Siberian mammoths, counteracts evil spirits; *Tridacna Gigas*, the giant clam, protects against sterility, and is the symbol of spiritual rebirth; Akar-Bahar, or black coral, is a powerful talisman against black magic and for this reason is commonly employed also

in necklaces and bracelets; water buffalo, rhinoceros or deer horn symbolizes strength, sexual potency, fertility and authority and is believed to be an aphrodisiac as well as being a purifying agent; iron, whether from the Earth or the Sky, has the dual effect of warding off ill-luck, but also of being its vector; gold is a symbol of knowledge and immortality; silver is linked to the moon-water-female element triad and symbolizes purity. The same applies to a number of other materials, such as marine ivory, mother-of-pearl, buffalo and whale bone, brass, coconut fiber, and *suasa*, an alloy of gold, silver and copper. But the most prized material of all is wood, whether ebony, Cassia, teak, *Murraya*, sandalwood, or *Kleinhovia*—all scented, prime-quality woods with splendid and unusual grains, often coming from trees inhabited by a spirit, which helps increase the power of the kris.

The figures represented on the hilt are often extremely enigmatic, their origin and meaning having been lost with the passage of time. Examples of these are the ancestor figures or long-haired demons sitting on a *tumpal* throne, typical of eastern Java and its northern coast. The *tumpal* is a triangle, often shown alternately upside down at the base of the hilt, and it represents the ancient Indonesian symbol of the mountain, the tree of life and the male and female principles. But similar mysterious figures are legion, and include the abstract hilts of central Java, which perhaps represent an ancestor figure after undergoing the extreme stylization typical of Islamic art; Ganesha, the elephant-headed Hindu god, found hidden among leaves and flowers in the style of Cirebon; the *Jawa Demam*, the so-called Feverish Javanese, the Sumatran figure which might in fact be Vishnu's divine mount, the eagle Garuda, as it might be Garuda himself depicted in the hilts of Lampung or represented while flying in the sea birds hilts of Sulawesi.[1] Then there are the figures associated with the *Wayang*—the shadow theater—like those known as *Nyamba* in eastern Java, and the hilts of Madura with their finely carved bloom of the ginger plant, and the legendary winged horse *Jaran Semberani*.[2] Sumptuous gold hilts were once the exclusive preserve of kings and princes, in accordance with the always scrupulously observed *adat* rules, while in a sense at the opposite extreme are the enigmatic *gana*, which are made out of materials themselves shaped like animals or human beings and believed in Java to be self-manifesting forms.

Lastly, the explosion of Hinduism in Bali is expressed in the kris hilts through the vast array of demons, deities and mythical heroes, including Bayu, god of wind and breath, the demon Nawasari, who carries the flower of the Buddha and Shiva on his back, and the guardian demons of the kris, Kocet Kocetan, an insect or figure in Balinese mythology

and Bhima, the great and revered hero in the Mahabharata.[3] Every hilt in the Lanfranchi Collection illustrated in this book is antique, and is fashioned with the greatest care, skill and understanding, as befits an object whose purpose is to increase the power of the kris and to give its owner the power to control it and to keep him in touch with the gods and the ancestors.

Looking at these artworks with fresh eyes, we feel that perhaps we too can cross the impassable threshold between the visible and invisible worlds, the line which the peoples of the Archipelago cross with great ease.

The world of the kris is made up of these two dimensions and it can be understood only after first negotiating the transition, by lifting the dark veils hiding the spirit of ancient Indonesian artifacts, from the little *pusaka*, little and precious objects such as the porcelain dishes found on the beach, cast ashore from some Chinese wreck, to the valuable *geringsing* Balinese cloth, the double *ikat*[4] which keeps evil spirits and disease at bay, and the *Wayang* puppets, animated and controlled by the *dalang*, who has a priest's powers, and the *mamuli*, the earrings of Sumba, linked to the spirits of the ancestors and the procreative power of the female sexual organ, or the sacred iron *gamelan selunding*,[5] which the Balinese believe to have mysteriously come from the sea… and finally the kris itself. Indeed, it is the kris which more than any other object transmits and represents the spirit of the Archipelago, and Malay peoples considered it a weapon of unrivaled potency, a bridge to the imperceptible.

But a brief comment needs to be made before describing the object in detail: times have changed and no man in present-day Malaysia or Indonesia would dream of going around with a kris in his belt; in any event, a number of beliefs have fallen by the wayside. Even so, out of respect for tradition, this introduction has been written in the present tense, although the past tense would be more suitable.

Considered from the point of view of the visible, the kris is a dagger used in combat at close quarters. Its blade is immediately recognizable whichever island it comes from, and is so distinctive as not to be confused with any other. The feature that makes it so special is the *ganja*, the asymmetric section constituting the base of the blade itself, and from which it is generally detached.

A kris blade can be straight or wavy. The straight version is thought to be the more ancient and is certainly older than the wavy type, which can have anything from one to twenty-nine curves. There is always an odd number of curves, the only exception being the number twelve, which appears in certain blades, perhaps because this figure represents totality, "unity in diversity", a motto which is very popular and strongly felt in Indonesia.

A kris can have a variety of shapes (there are said to be hundreds of them), depending not only on its straight or sinuous outline, but also on the various details carved or engraved on the blade.

The beauty and status of the blade comes from the *pamor*, a word which has two meanings: it can refer to iron alternating with nickel, or to naturally occurring iron alternating with meteoric iron used to make the blade; it can also refer to the silver pattern appearing on the blade surface after forging. In order to obtain this particular effect, the smith heats layers of iron and nickel in the fire, creating a bar which is then hammered and bent into a u-shape, then reheated, hammered and folded once again and so on for at least sixty-four layers in the case of a good-quality kris. It is said that some special, supreme quality krisses have fully 4,098 layers. The result of this painstaking work is a damascened blade of great beauty.

The smith forging the blade is called *Empu*, or master. He has to belong to a family of kris makers, have a profound knowledge of forging, engraving, incising and carving techniques, an intimate understanding of human nature, and must possess the spiritual qualities necessary to prepare himself through prayer and ascetic practices, such as fasting and retreat from the world, in order set foot in the sacred space of the forge. The forging takes place only on certain propitious days, and is generally carried out in silence, with the help of a pair of assistants. The craftsman interrupts the procedure only to pray, and to make offerings to the spirits of the ancestors, so as to ensure a successful outcome in the fashioning of the new weapon.

It behooves a true *Empu* to have a thorough knowledge of the person who has commissioned the kris, so that he can create a blade that perfectly matches the person's character, and is appropriate to his rank, occupation, and horoscope.

In the Indo-Malay world, smiths have always been held in great esteem, and in the period of the kingdoms and sultanates, when the most skilled *Empu* worked at court, they enjoyed considerable privileges, including permission to marry a Javanese girl of noble birth.

The *Empu* does not make the scabbard of the kris, as this is the job of a specialist craftsman who has a highly developed sense of proportion and great experience in carving wood. For kris scabbards are made of wood, although they may be partially or entirely covered in a layer of engraved or embossed metal. These scabbards have a very unusual shape, with

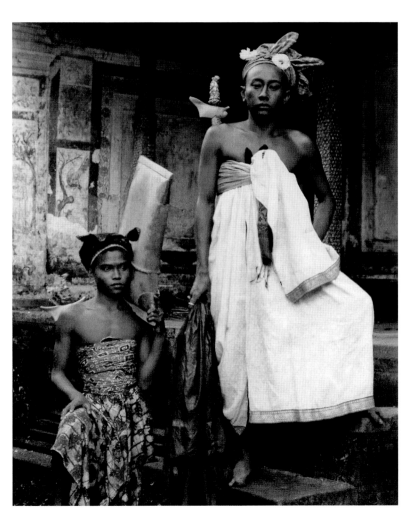

Balinese prince and his servant;
they both wear a kris

the top being shaped like a boat—a feature repeated with only tiny variations throughout the Archipelago. In Java there are three main types of scabbard: ceremonial scabbards for important events, those used on informal occasions, and those for everyday use. On this island the color of the part of the scabbard actually containing the blade is a mark of the owner's position at court: bright red indicates the wearer is the king's son or grandson, dark red is for other relatives, green for high-ranking courtiers, and black for the lower orders.

Krisses are present at all traditional ceremonies held by peoples in the archipelago: rites marking the seventh month of pregnancy, the severing of the umbilical cord (around seven days after birth), circumcision (among Moslems), weddings, where a kris can (could) legally represent the groom, in performing *sati*⁶ among the women of Bali aristocracy, in executions, in funerals and in the *puputan*, ritual suicide, or rather "fight to the death". This is the weapon used by those who run *amok*, the frenzied lust for blood which grips certain men in Malaysia, as well as being used by Balinese dancers who fall into a trance during the ritual performance and stab themselves with a kris. This weapon is also worn by the important figures in the Wayang shadow theater, where the hilt is conventionally represented by a garland of stylized flowers.

During festivities and in propitiatory rites, such as those performed by peasants to protect the harvest, and by fishermen to ensure a good catch, the preferred weapon was a short kris about twenty-seven centimeters long, known as a *kris sajen*.⁷ The hilt represents the ancestor figure, sometimes standing and sometimes seated in a squatting stance, with both body and face poorly defined, and an appearance which could be described as archaic. The design of this kris goes back a long way to times when ancestor cult was still current, and it is regarded as a powerful magic amulet.

From the point of view of the invisible, the kris is a weapon imbued with spirit and power. The role of the *Empu*, the intermediary between the visible and invisible worlds, is to use the fire of the sacred space of the forge to transmit the spirit of the ancestors to the kris, and thus make the weapon powerful. Through the mystical and ascetic power of the *Empu*, the spirit can enter into the blade being forged, and turn it from a mere weapon into a living entity. In certain Indonesian traditions, it is believed that when a kris is inherited—*kris pusaka*—it contains three spiritual forces: the spirit of the *Empu* who forged it, the spirit of those it has killed, and the spirit of its first owner, which is the most important as this is the ancestor's

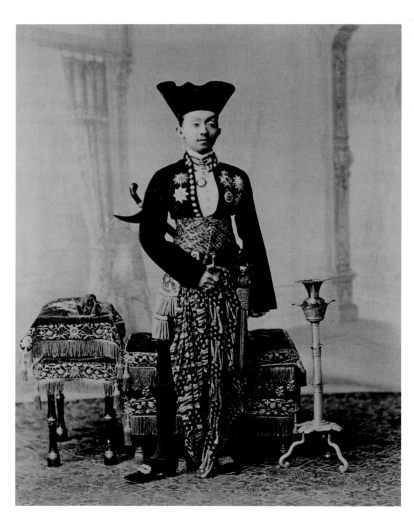

Paku Buwono X, Susuhunan
of Surakarta.
End of the 17th century

spirit. In this way, this sacred heirloom becomes the link between a man and his ancestors, a bridge between the past and the future, through the present.

A *kris pusaka* is thought of as a living being, and is given its own name and an honorary title like *I*, *Ki* or *Kyai*. *Kyai* is an honorary *Kawi*[8] title, which can be roughly translated as "venerable," and applies to the most highly respected Islamic scholars and certain objects of worship.

A weapon which thanks to its spiritual energy becomes the invisible agent behind the ruler's actions, legitimizing his authority, is truly worthy of veneration. It is the most important of all the royal regalia and protects not only its owner but the entire community against all kinds of dangers, including epidemics, natural disasters, and black magic.

The blade is the heart and soul of the kris, and has to be honored, respected and scented with jasmine, sandalwood or fragrant cananga (or ylang-ylang) oil, and cleaned on specific days of the week and year. Its *pamor* has a power that can act for either good or evil, or it can be hard to govern and thus not suitable for all. As a result of the category into which it falls, a kris brings its owner good or ill luck, attracts wealth, or protects against dangers, magic, evil spirits, and so on. A person acquiring a kris can find out whether he is lucky or not by means of certain calculations performed using his thumb or a strip of pandan leaf. According to tradition, in order to find out a kris's "content"[9] the object should be put under the pillow at night, and the dream it conjures up while its owner is asleep reveals the kind of power the kris possesses. It is certainly possible to do away with an unlucky kris, but such is the respect and deference accorded to the weapon that it must first be purified, wrapped in a white cotton cloth with flowers and incense, and finally thrown into a river or into the sea; or alternatively, as happens nowadays, it can be bequeathed to a museum, thus making this example of the heritage of humanity accessible to everyone.

The type of iron used in forging the blade serves to increase a kris's power. In this regard meteoric iron is the optimum, but there are other types of iron which make their owner invisible or invulnerable in battle, or ensure that he will always be obeyed.

A wavy blade is associated with the movement of the snake, *naga*, while a straight blade is linked to the snake in meditation. The *Empu* takes special care in creating a curved blade, especially in Java. In order to comply with the requirement that the kris match the person for whom it is being made, he has to ensure that the number of curves corresponds to the person's horoscope and to his personal characteristics, and that it is in harmony with natural phenomena and with the rules governing Javanese numerology. For example, a

kris with three curves is obviously linked with the number three, which is related to fire and thus to Agni, the god of fire, the fire of the forge, and by extension to torches, lamps, lightning and to the ardor of passion. So it goes without saying that a good *Empu* will never make a kris with three curves for a fearful, timid, cold person.

Following this theme of the invisible: from an extreme, esoteric point of view, the blade represents the lingam, the *ganja* the yoni,[10] and the scabbard the temple of the lingam itself. The scabbard is an essential component because not only does it protect the blade and its power, but it also acts as a shield against the energy released from the kris.

The hilts with the closest relationship with the invisible world are those from ancient eastern Java, from the *pasisir*—the northern coast between Cirebon and Surabaya—from western Java and from Bali. These are richly endowed with symbols and hidden meanings: the sun and moon, the vase with the elixir of immortality, the *tumpal*, the spiral, the snake, the Greek key motif known as *pat likur*, the flower of Shiva, the navel which is regarded as the seat of vital energy, and the invisible third eye, sometimes marked by a gemstone. There is no end of symbols associated with the kris, which is the object considered to have the most of all.

The kris is the most exalted of all edged weapons. Its esoteric and social importance has earned it pride of place in the Indo-Malay world, and it is precisely in order to safeguard this status that it has been included among the treasures of the world's cultural heritage.

1. … but do not birds also lie at the heart of the ancient myths of Indonesia and Oceania?

2. The winged horse, also known as Kuda Semberani (or Kuda Panoleh if its head is turned round) is a typical Madura motif. This was the emblem of the Prince of Sumenep and only members of the royal household could have this horse on their kris hilts. This ban was lifted in the 19th century.

3. The Mahabharata, together with the Ramayana, is the greatest Indian epic poem. It comprises eighteen books and tells the story of the great war between the Pandava and Kaurava, cousins in the same Bharata dynasty. This is a poem of profound philosophical, religious, ethical and cultural significance, one of whose sections is the Bhagavad Gita, a sacred text of Hinduism. There is also an Indonesian version known as the Bharata Yudha, which was written much later and describes only the war between the two groups.

4. Ikat is a method of dyeing in which selected parts of the cloth are knotted to prevent them being exposed to the dye. In simple ikat the dye is applied only to the thread of the warp, while double ikat includes the weft.

5. The gamelan is a set of Indonesian musical instruments made up of metallophones, xylophones, drums and gongs. The metal used for these instruments is generally bronze, although the gamelan selunding is made of iron. It is considered a sacred instrument and is almost never shown in public. No one can touch it without express permission and very few musicians actually know how to play it. It is said in Bali that the sound of the gamelan gong can breach the barrier between Sekala, the visible world, and Niskala, the invisible world.

6. In which a widow was expected to throw herself on her husband's funeral pyre and be burnt with him, as in India.

7. *Sajen* means offering, or sacrifice.

8. An ancient Javanese sacred language and script, also used in Bali and Lombok.

9. "Content" is the literal translation of the Indonesian word *isi*, which stands for the undefinable spirit-power-character of the kris.

10. The lingam is the phallus, symbolizing Shiva and male creative energy, while the yoni is the female sexual organ and symbolizes the goddess and female creative energy.

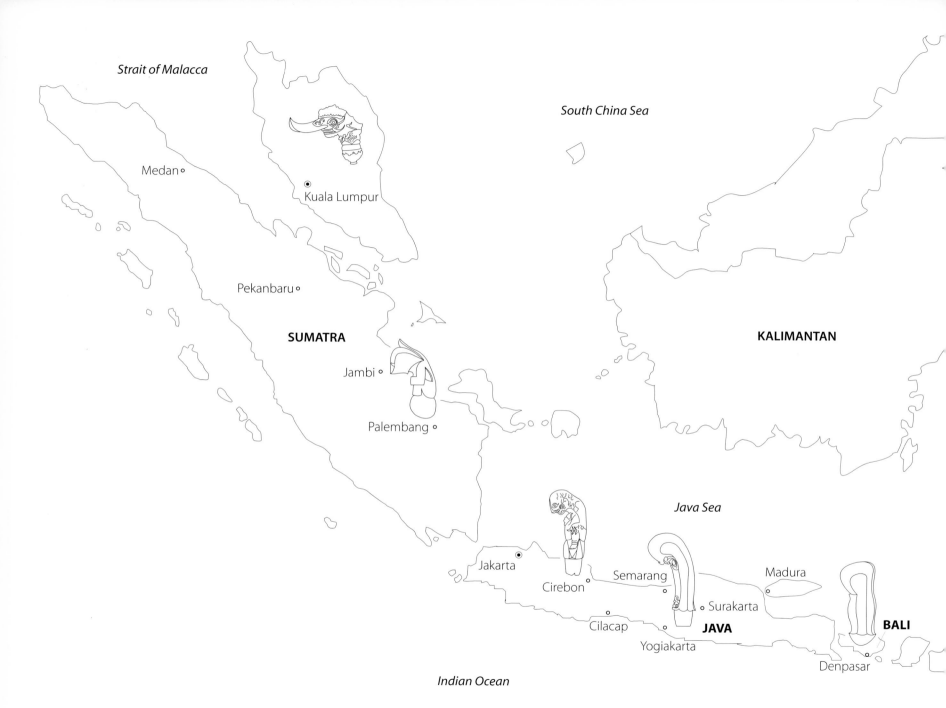

Strait of Malacca

South China Sea

Medan ○

Kuala Lumpur ⊙

Pekanbaru ○

KALIMANTAN

SUMATRA

Jambi ○

Palembang ○

Java Sea

Jakarta ⊙

Madura

Semarang

Cirebon ○

Surakarta ○

Cilacap ○

JAVA

BALI

Yogiakarta

Denpasar ○

Indian Ocean

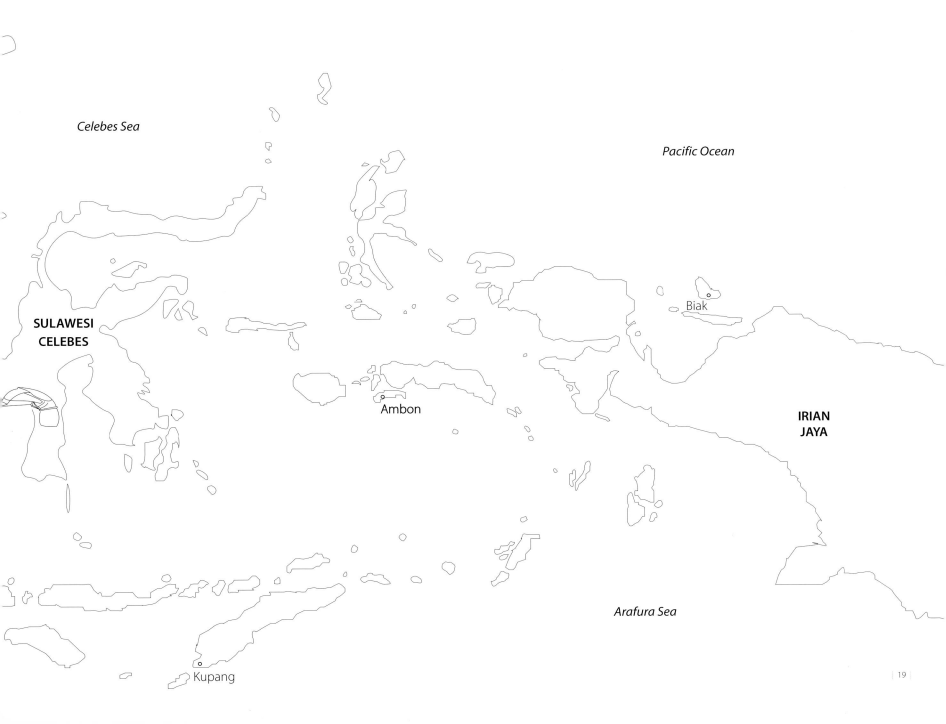

Celebes Sea

Pacific Ocean

SULAWESI
CELEBES

Biak

Ambon

IRIAN
JAYA

Arafura Sea

Kupang

The word *sajen* means offering or sacrifice, and indeed these small krisses were used in ceremonies held before planting rice, blessing the village, or to protect the harvest, or the catch in the case of a fishing community, as well as serving as an amulet for individual people. They are still made entirely of forged iron and apart from a few exceptions they are never over 27 cm in length. The hilt is rather flat and generally represents an ancestor. In addition to these sacrificial krisses, which go back to the time of the Majapahit empire (eastern Java, 14th cent. to ca. 1520), when ancestor worship was common, other similar but much longer ones measure between 36 and 42 cm. These heavy daggers had blades that were very like the krisses we see today, and were designed to be worn at court. In the West both types of kris were wrongly known as kris Majapahit.

KRIS SAJEN
Iron blade and hilt
H. 30 cm | 7 cm

The kris *sajen* illustrated here is 30 cm long, including a 7 cm hilt. The figure is reasonably detailed and shown in the typical position of the ancestor (squatting with hands on the knees). The headwear is of the type worn by Panji, the legendary prince of eastern Java, and the hair sweeps down the back of the head and down the neck, where it meets other carved lines perhaps suggesting clothing. The blade is very interesting, with its slight lateral depression, and *pamor* engraved with vertical lines, said to ward off natural disasters. A further triangular *pamor* on the base symbolizes the peak of the sacred mountain and protects against all visible and invisible dangers, including black magic and evil spirits. Kris *sajen* is considered to be full of magic powers and as such is also worn by women as an amulet, often tucked away among the folds of their sarong.

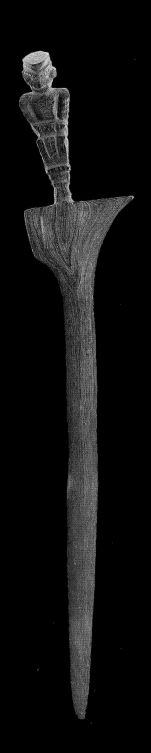

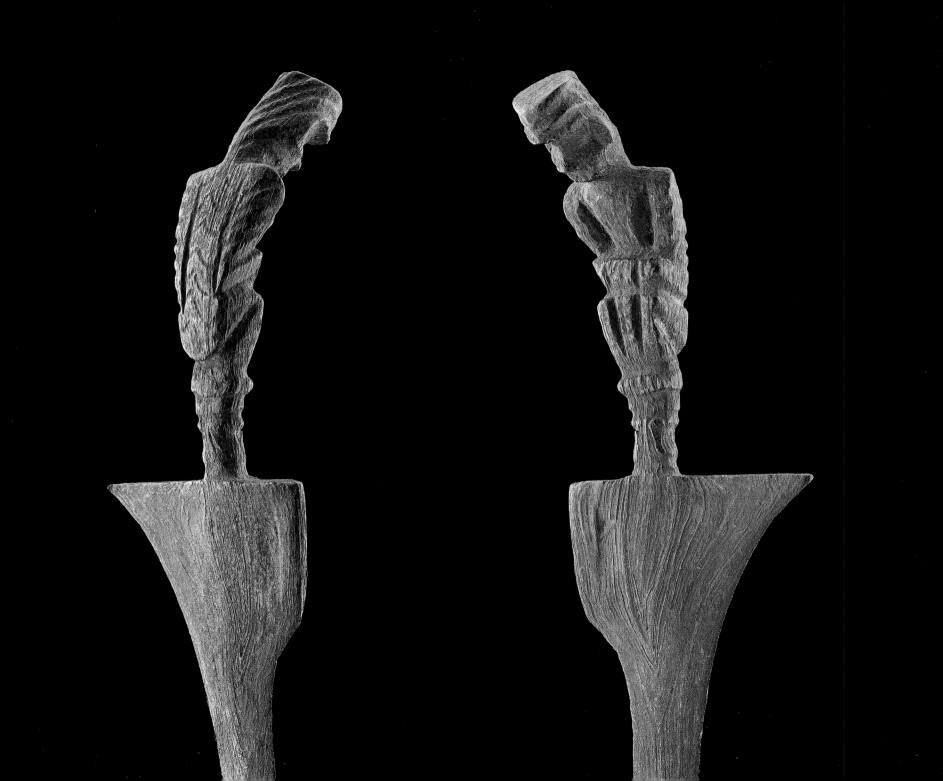

PAGES 23-25 >

HILT FROM THE KARIMUNJANAWA ISLAND

Ivory

H. with base, 12 cm

Stylized figure with four-pointed crown and intricately carved motifs all over the body: two flowers on the shoulders and two flowers on the back with curling, upturned petals, and four decorations with a highly unusual design made up of two tendrils ending in a bud whose tip almost touches the point of the *tumpal* at the base. The bun at the top of the head gathering the figure's hair is in the form of a flower like those on the shoulders and back. The carving on the rest of the body and on the triangular face is made up of tendrils with tiny flowers, all in high relief. The decoration on the back of the figure [page 24, left] repeats the central motif on the front. The figure rests on an engraved silver base. Some experts believe this hilt to come from north-eastern Sumatra.

HILT FROM THE NORTH-EASTERN COAST OF JAVA – *Paisir*

Marine ivory – sperm whale tooth

H. 10 cm

This demon, whose sinister scowl is halfway between a smile and a snarl, is embellished by an extremely elaborate floral decoration covering the whole body, by a winged crown and pretty rosettes [page 23, detail]. A jewel similar to those found in figures on other hilts is carved in the middle of the forehead, between the thick eyebrows, and may symbolise the third eye. The right foot protrudes from the vegetation and the arms are crossed in the stylised manner typical of the area and only the right hand is visible. The belt round the figure's waist is composed of little flounces, producing a lace-like effect. On the reverse is a large open spiral scroll.

The inclined head is often meant to refer to the three virtues that are especially valued in Indonesia: patience, devotion and steadfastness.

PAGES 26-27 >>

HILT FROM MADURA

Marine ivory – Putrasatu style

H. 9 cm

A seated figure with large flower at the base, set on a little garland of small rings. The object is completely covered with a rare floral pattern and the face is made up of four leaves folded back on each other and the tangled hairstyle is held in place by a headband with a central flower-jewel. The enveloping leaves suggest the folded arms that are typical of this style. The carved design on the back is very elaborate, the motif changing five times in just seven centimetres [page 26, left].

HILT FROM THE NORTHERN COAST OF JAVA/MADURA – *Pasisir Jawa/Madura*

Ivory

H. 9 cm

This unknown demon [page 26, right] is completely covered with vegetation, a vegetation carved with extreme care, leaf by leaf, tendril by tendril, four of which make up the eyes and moustache by way of the nose and doing just enough to suggest the face. The elegant hairstyle can also be made out, ending in two large spirals at the top of the head. The figure is based on the classic triangles. A point of both the front and back ones touches a pine cone, the one on the front being surrounded by leaves, while the one on the back is enclosed by entwined branches.

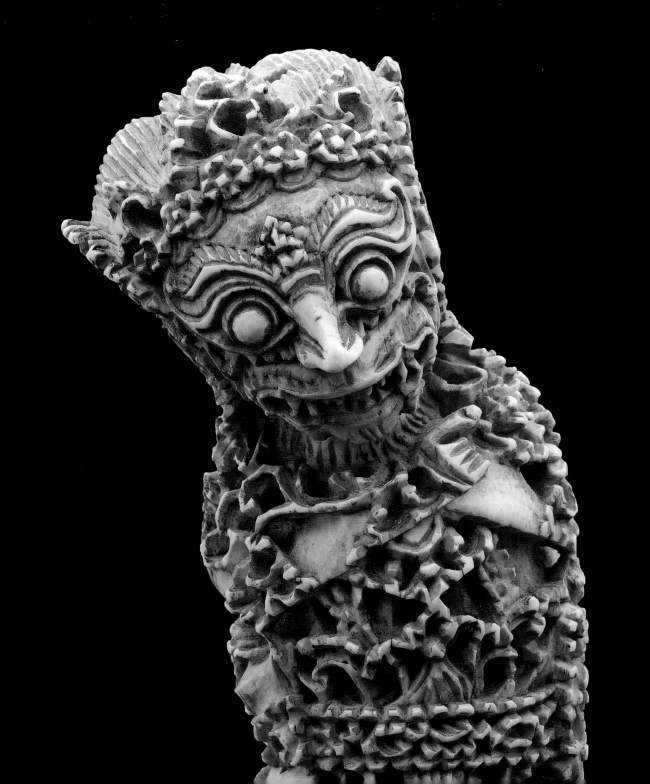

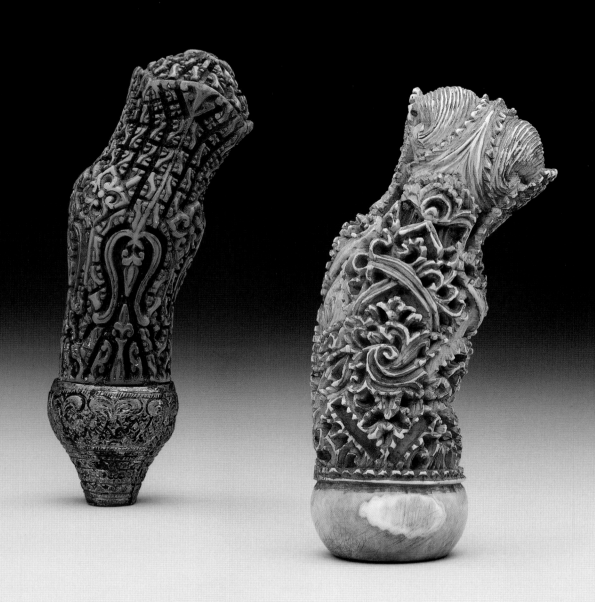

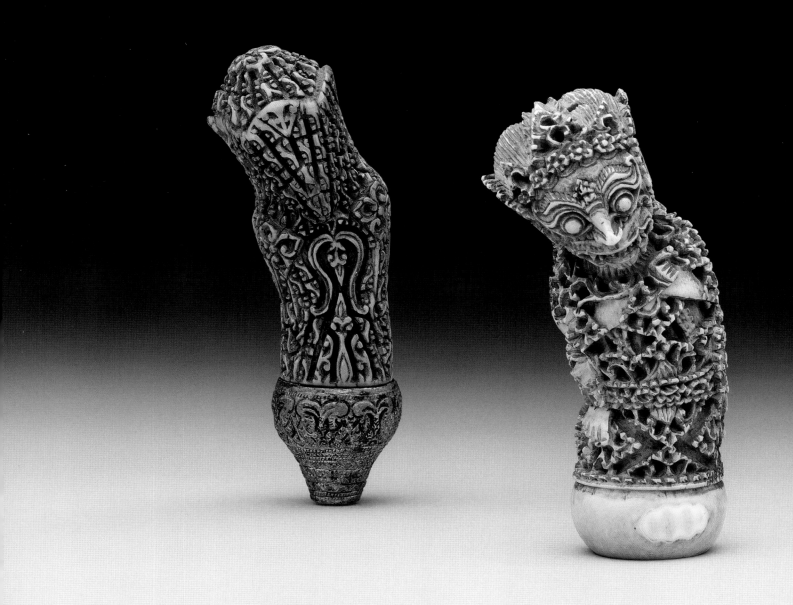

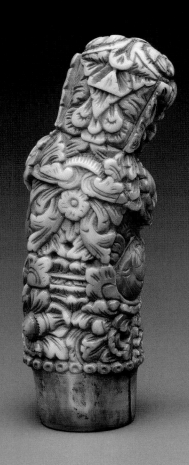
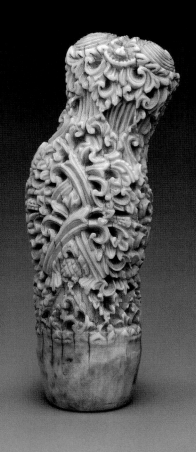

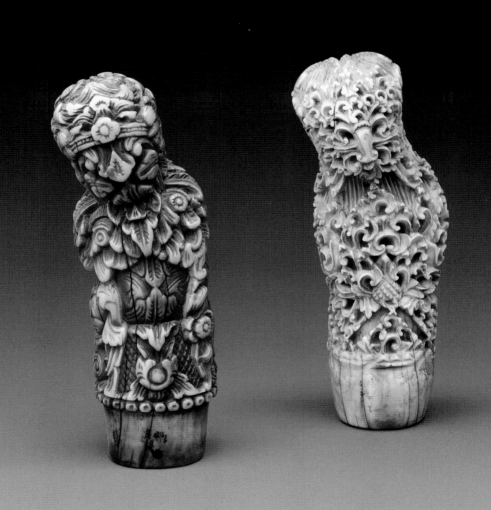

PAGES 29-31 >
HILT FROM THE NORTH-EASTERN COAST OF JAVA – *Pasisir* | HILT FROM EASTERN JAVA
Ivory
H. with base, 10.3 cm | H. 8.5 cm

A superb example of the demon/ancestor type of figure [page 30] . Although the mouth has fangs, it bears a smile, and the long hair is held in place by a small crown with central flame-like jewel. The lozenge sash held in place around the figure's waist by a belt with a meander pattern is especially elegant. The belt forms two triangles above and below it, the tip of the lower resting on the top of the *tumpal* on the base, thus creating two further triangles and maintaining the rhythm. The meander motif is often found on the finest cloth in Indonesia, where it is known as *pat likur* and symbolizes thunder and clouds and is associated with fertility.

Time and the many hands which have held this object [page 31] have smoothed and polished it as the sea burnishes a pebble on the beach, without however obliterating the beauty of its carved decorations. The flat, perforated nose is highly unusual and makes the head look almost like a skull, compounded by the Garuda beak. On either side, on the figure's ears, is the typical Indonesian leaf-shaped jewel worn by high-ranking persons. The figure wears a triangular necklace mirroring the central *tumpal* in the base, balancing large, inverted C scroll decorations on its tip.

PAGES 32-33 >>
HILT FROM EASTERN JAVA
Bone or horn
H. with base, 10 cm

This figure represents Bhima, the great hero of the *Mahabharata*, identifiable by his distinctive hairstyle combed back into a big curl surmounted by Garuda's beak, typical of the five Pandava brothers as depicted in Indonesian iconography, and by the same fearful long nail on his left hand encountered in his father Bayu, god of the wind. In his right hand he holds the flower of Shiva, and wears bracelets, anklets, earrings, and a jewel on his forehead. A half-moon can be made out between his bulbous, vacant round eyes, perhaps the mark of the third eye. Bhima is shown here with a reassuring smile, seated and leaning slightly forward on the *tumpal* motifs richly decorated with the same "burning eye of the sun" jewel on his forehead. This is a splendid example of the Hindu-Javanese style.

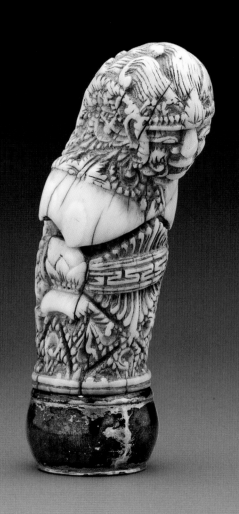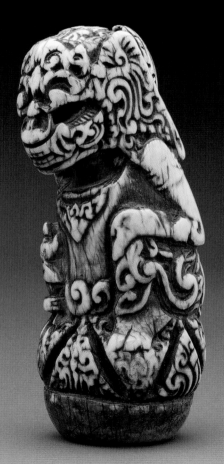

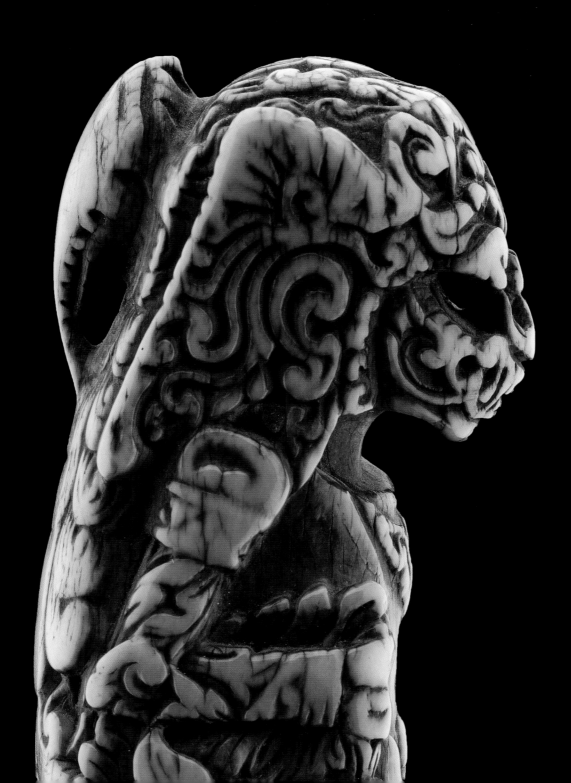

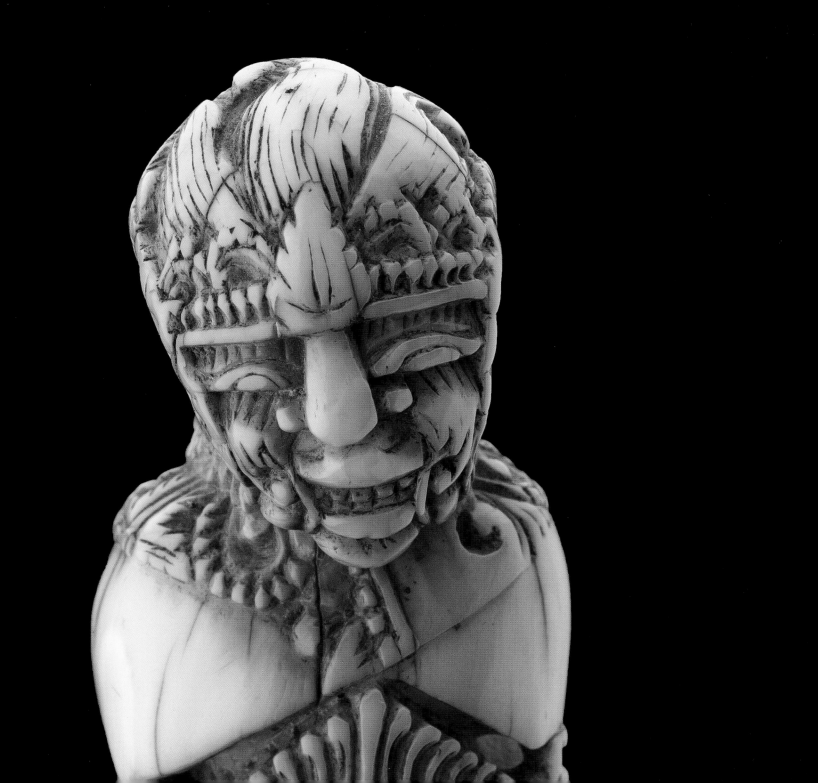

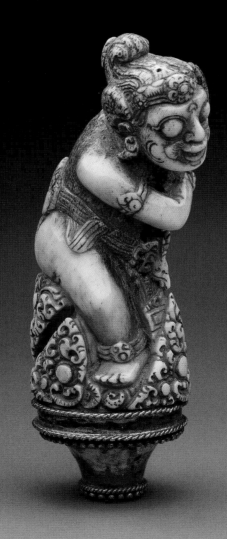

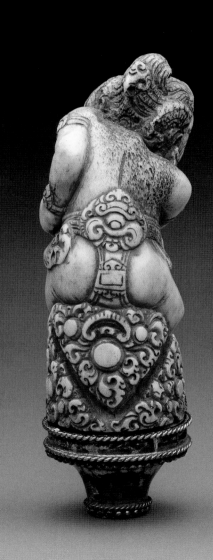

PAGE 35 >
HILT FROM EASTERN JAVA
Bone
H. 7.5 cm

An interlaced headband holds back this figure's long curly hair.
The mouth and big, flattened nose lend the face a certain heaviness, but the barely outlined eyes makes the figure appear as if it is in another world, almost in a trance. He is seated in the typical squatting position of the ancestor on a round base made up of *tumpal* motifs decorated with engraved C-shaped scrolls, and wears a long triangular necklace. This extraordinary hilt is very ancient and is redolent of a Javanese world which no longer exists— Yavadvipa, the Millet Isle, as Java was known in Sanskrit.

PAGES 36-37 >>
HILTS FROM JAVA
Wood | Wood | Bone
H. 8 cm | 8.3 cm | 8 cm

It is not easy to see this figure depicting an old woman, bent over and holding a flower in her hand, mounted on a kris [page 36, left]. She is wearing the classic long Javanese dress: the long skirt (*kain panjang*) and the short blouse (*kebaya*), while her hair is done up in a bun on the nape of her neck—also typical of Java. But why should such a small hilt have such a figure on it? Is it meant for a woman's kris, or *keris wanita* as it is called in Indonesia, or *patrem*, to give it its specifically Javanese name?

This slim hilt may represent a Wali, one of the nine saints who converted Java to Islam [page 36, center and page 37, detail]. The first Wali, Maulana Malik Ibrahim, was from Samarkand and reached Java in 1419. This figure has a beard and moustache and his hair flows down to his shoulder. He wears a long buttoned tunic and a turban made up of four coils whose loose end falls across his left shoulder. Wali is an Arab word meaning "he whom one may trust", or "friend of God". In Indonesia, the term has acquired the added meaning of "saint" and the expression Wali Sanga is often translated as "The Nine Saints".

This hilt from the north-eastern coast of Java depicts a figure hidden among flowers, foliage and tendrils, with only the face and large ears showing through, the effect being that of a framed portrait [page 36, right]. This ancient hilt is considerably worn, but the exquisitely carved floral decoration, with large, spiralling central branch and pretty eyelet motif encircling the base are still clearly visible.

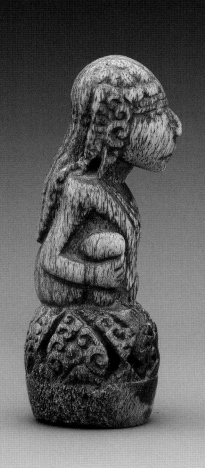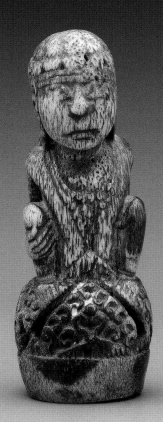

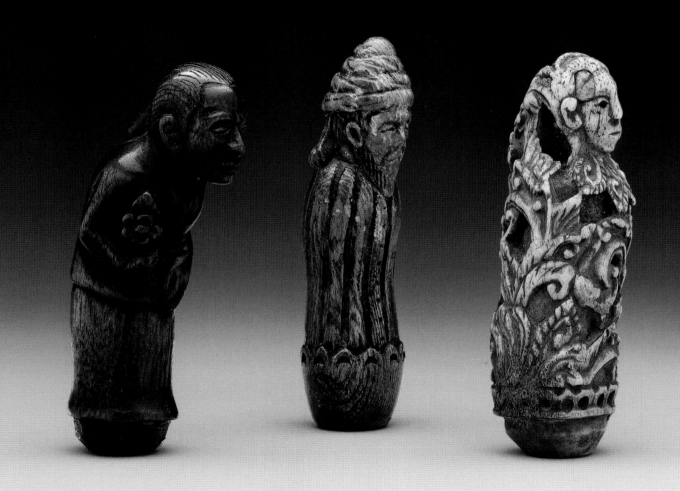

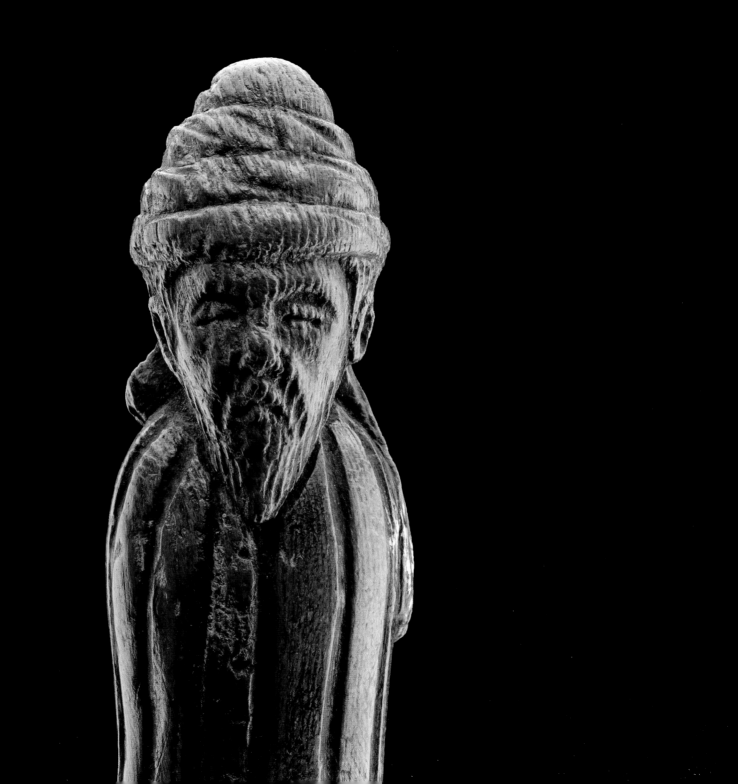

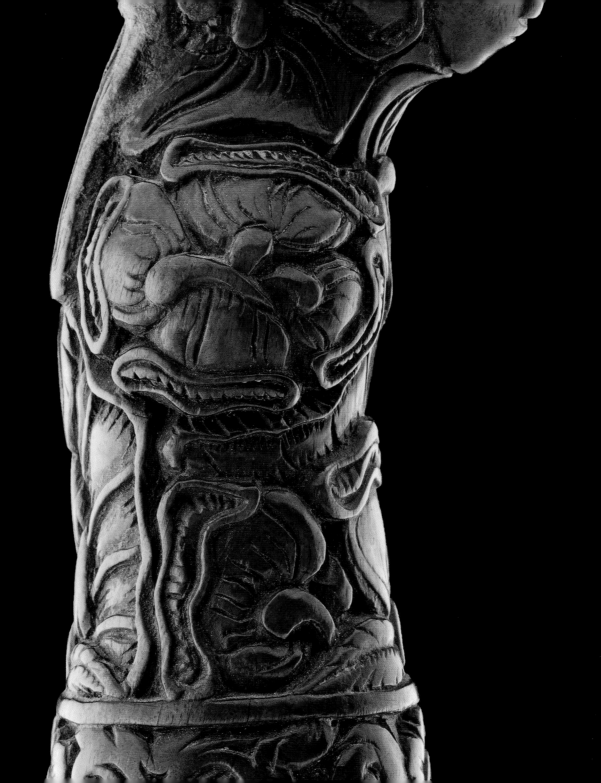

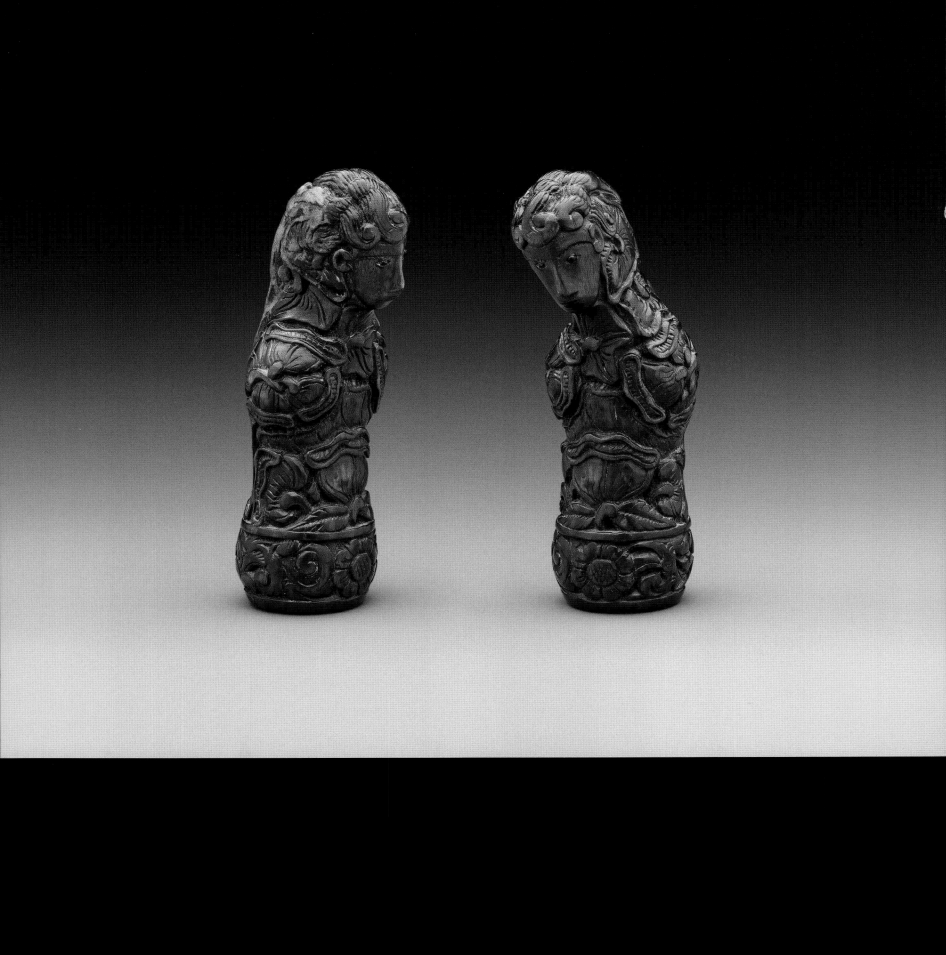

PAGES 38-39 <
HILT FROM MADURA
Wood
H. 9.5 cm

The type of wood used, the workmanship displayed, the eight-petaled flowers on the base, the large lotus blossoms on the front with a further two on the shoulders, almost like epaulettes, and the ear of rice on the back all point to an origin on the island of Madura. The figure has three sets of curls on the back, and more locks of hair sweeping over the forehead. The face is clearly delineated, with two tiny black stones set into the eyes and fully visible ears. The carving seems to have a rather sullen or doleful expression, which nonetheless achieves a striking effect among such exuberant and sacred vegetation.

PAGE 41 >
HILTS FROM THE NORTH-EASTERN COAST OF JAVA/MADURA – *Pasisir Jawa/Madura*
Wood
H. from 8.5 to 10 cm

These four hilts all illustrate a style typified by figures with their arms folded, the right elbow resting on the knee and the left on a sort of flowery stick, behind which appears a leg with an upturned curl in place of a foot. The flowery stick might in fact be meant to represent a shield, as could be implied by this figure's name in Madura: *putrasatu* (prince).
All four figures are covered in vegetation and are seated on *tumpal* motifs. As usual, they wear a long mustache and their hair is arranged in bands of curls and their faces are set in a laughing grimace.
The color of the wood varies, but the craftsmanship is uniformly of the highest standard, with a wide range of especially elaborate motifs.
This type of *demon/ancestor/prince* might simply be a minor Hindu god of vegetation.

PAGES 42-43 >>
HILT FROM MADURA | HILT FROM THE NORTH-EASTERN COAST OF JAVA/MADURA – *Pasisir Jawa/Madura* | HILT FROM WESTERN JAVA – *Cirebon*
Wood – *Pulasir*, cuirassier, style, or *Topi*, helmet | Wood | Ebony
H. 9 cm | H. 10 cm | H. 9.5 cm

This hilt is an unusual interpretation of the "cuirassier" style, which always includes a stylized figure with a helmet, belt and military epaulettes. In this figure a face with a long mustache can be made out under the helmet, the epaulettes have been replaced by fringed flowers [page 42, detail, and page 43, left] and the body seems to be protected by a sort of mailed armor with the classic *tumpal* triangles at the bottom. The base was intended to be overlaid with metal, as appears in certain ancient hilts from the island of Madura.

This extremely rare hilt, with its narrow, elongated face and protruding tongue, also belongs to the "folded arms" style, except that in this case the figure lacks the legs on which to rest the arms, which are laid over two leaves instead [page 43, center]. The usual triangles at the base are replaced here by five openwork ovals encircled by a lace decoration.

The arrival of Islam in the Indo-Malay Archipelago, with the consequent ban on depicting the human or divine form, forced Ganesha, the much-loved elephant-headed Hindu god worshipped because "he is the remover of obstacles," to assume an unrecognizable appearance, with leaves and tendrils swathing his body and ears, leaving only his chief feature, his trunk, visible. The old gods always win in the end!
It is worth noting the large spiraling C at the base, which is typical of Cirebon [page 43, right].

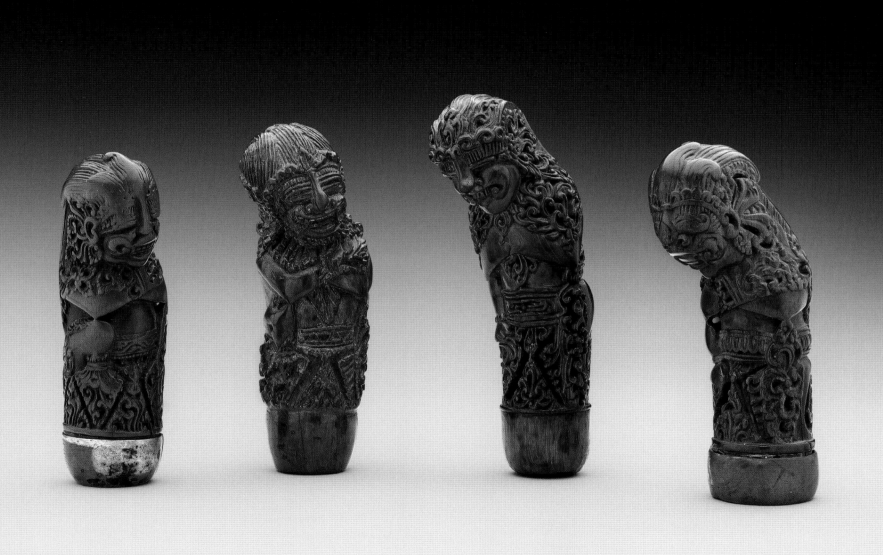

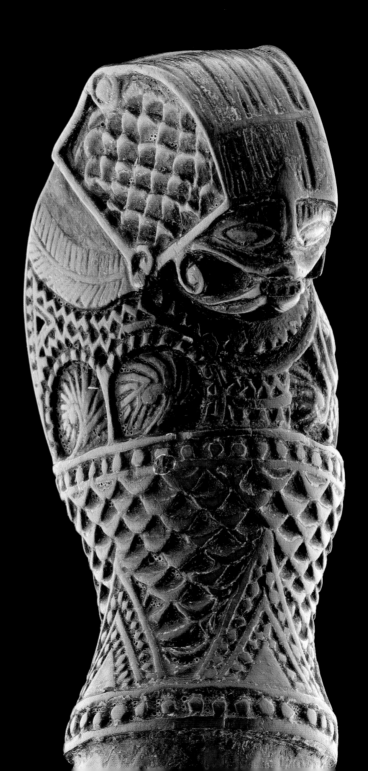

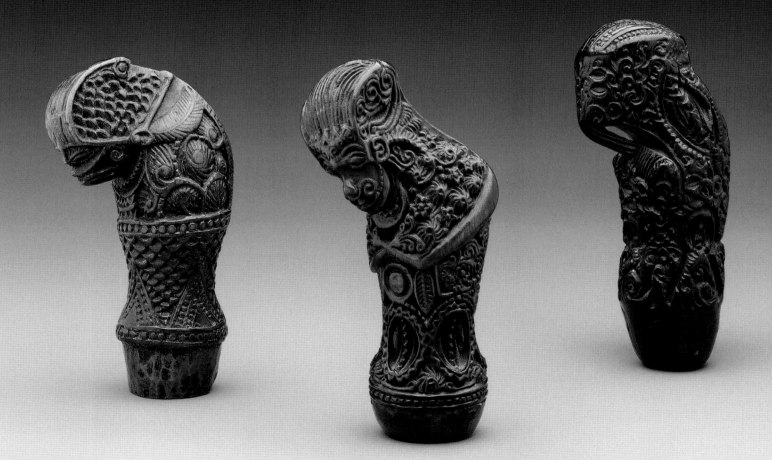

PAGE 45 >
HILTS FROM CENTRAL (Jambi) OR NORTHERN SUMATRA
Fossil ivory
H. 12 cm | H. 13 cm

Stylization has been pushed to abstraction in these disquieting figures, to the extent that it is even hard to include them among the "Sumatran Durga style" of works, faceless and virtually formless. The material is extraordinary and creates a chiaroscuro effect that brings the figures to life without them even needing a body or facial features.
The size of these figures is out of the ordinary both in terms of height, 12 cm for the left hilt and 13 cm for the right, and width, 3.8 cm and 5 cm at their widest point, respectively.
Fossil ivory tends to be brittle, and is therefore awkward to carve, but on the other hand it lends an object its own special magic and allure.

PAGES 46-47 >>
HILTS FROM BENGKULU, SOUTH-WESTERN COAST OF SUMATRA (or Jambi area)
Wood – Ivory – Veiled Durga style
H. 9.5 cm | H. 8.4 cm

This is a geometric stylization of a mysterious human figure with a featureless face. There are no firm indications of its origins, but some experts believe it portrays Durga, Shiva's great consort, who veils or conceals her face so as to avoid terrorizing those who dare look at her. For others, however, this is a crowned figure with the usual folded arms depicted in a squatting stance.
The whiteness of the ivory makes the figure on the right even more enigmatic and remote, while the wooden hilt, set on a highly original base, seems more graceful and less haunting.

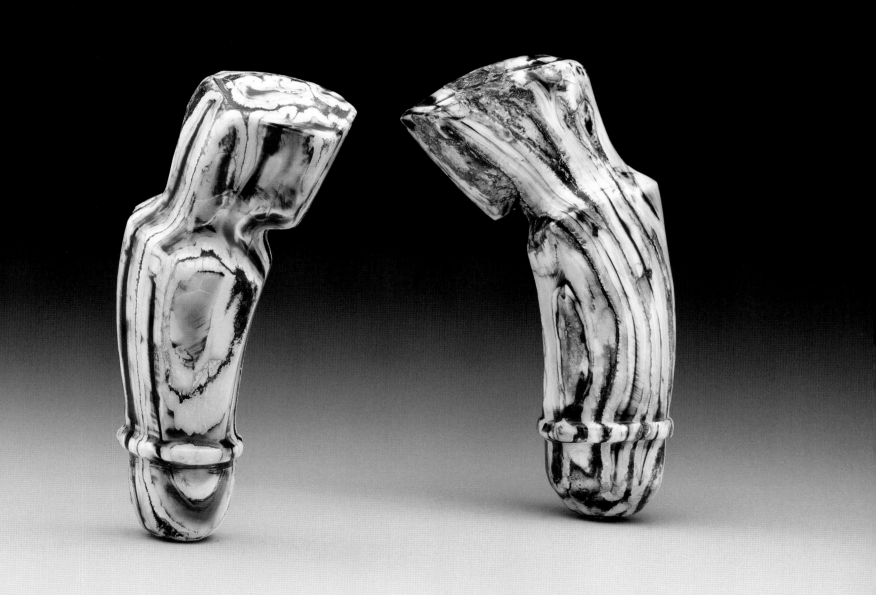

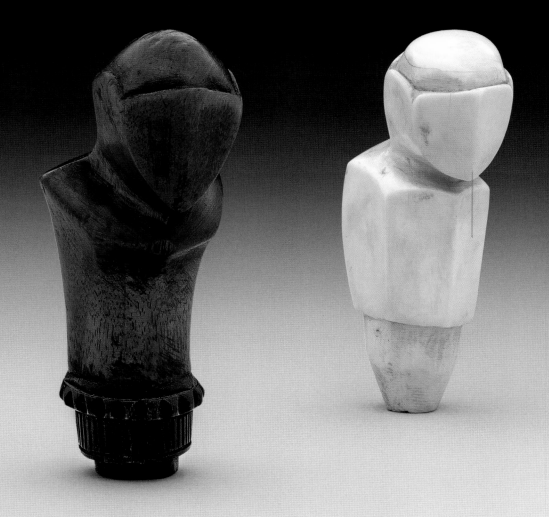

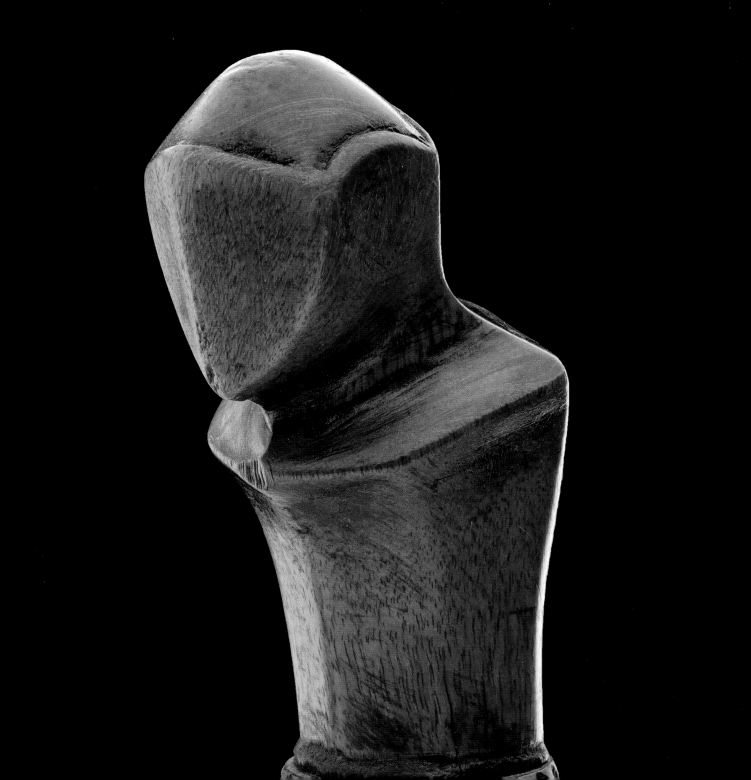

PAGE 49 >

HILT FROM CENTRAL JAVA – Surakarta (Solo)

Rock crystal

H. 8.5 cm

This hilt is made of extremely pure rock crystal, sovereign among minerals. It was undoubtedly chosen because it is regarded as affording protection and having regenerative powers by absorbing negative forces and activating positive ones. In addition to increasing the object's beauty, being able to see the blade tang embedded in the transparent crystal, would also have rendered explicit the merger of iron and crystal, both enhancers of benign powers. The small protuberance at the head of the hilt, which is typical of Surakarta, is barely suggested.

PAGE 50 >>

HILT FROM CENTRAL JAVA – Surakarta (Solo)

Wood

H. 10 cm

This hilt is in a style also used in eastern Java known as *kagoq* "intermediate", which is rather rounded, as opposed to the usual slim hilts from Surakarta. However, it retains its two chief characteristics, the engraved frontal masks and the point projecting from the upper mask, said to represent the tip of the head-scarf worn by the inhabitants of Surakarta, which hangs loose over their forehead.

It is worth noting that the artist has shaped the hilt into six planes: a central curved plane, two lateral planes and three rear planes, thus increasing the effect of the sheen and radiance of the wood used, *tayuman* (*Cassia laevigata* Willd.), the wood of choice in Java.

PAGE 51 >>

HILTS FROM BALI

Cecekan-Cekah Redut style | Areng wood

H. 11.0 cm; max. width 4.8 cm | H. 12.3 cm; max. width 5.5 cm

A magnificent hilt from Bali made of Areng wood, which resembles ebony, with tight folds running the length of the body like the bellows of an accordion [page 51, right]. The upper part is smooth and made up of two large lateral lobes and a central one starting at the rear. The base is slightly hexagonal. Hilts of this kind used to be worn by soldiers.

Areng is a palm wood, and its very fine texture and dark color make it similar to ebony.

This *Cekak Redut* is also made of wood, but its folds are slightly looser, thus putting into greater relief the triangles formed at the sides and back, which are barely noticeable in the other hilt on this page [page 51, left]. The "head" is composed of two flat side panels, two almond-shaped designs and five lobes, the middle one of which ends in a triangle. The two tiny curls looping round to either side of the figure are extremely interesting: may it be that Bali also shared the Javanese tradition of using curls on kris scabbards to indicate that the owner was the ruler's son or grandson? This might be the case because this type of hilt was also worn by the Balinese nobility serving in the Dutch army.

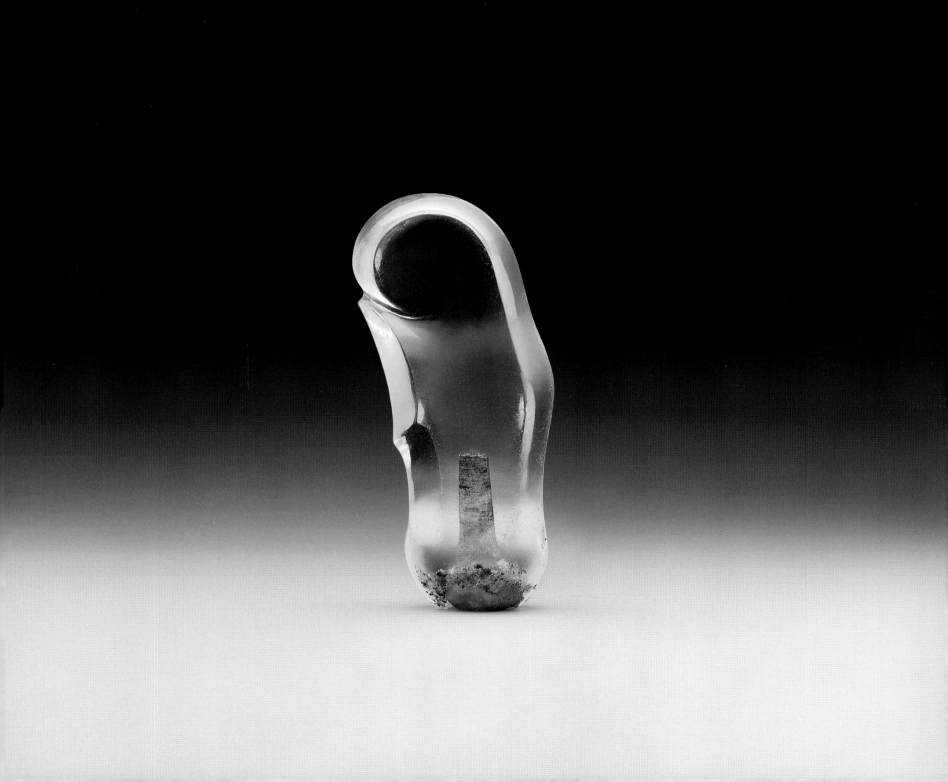

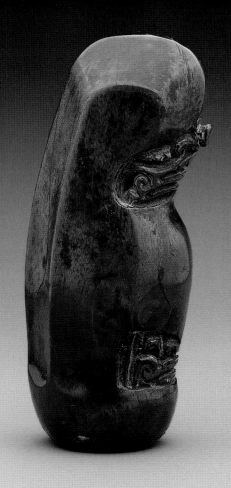
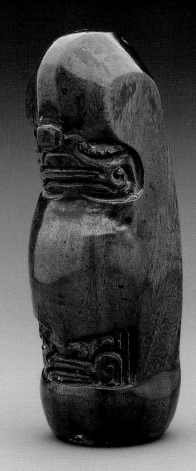

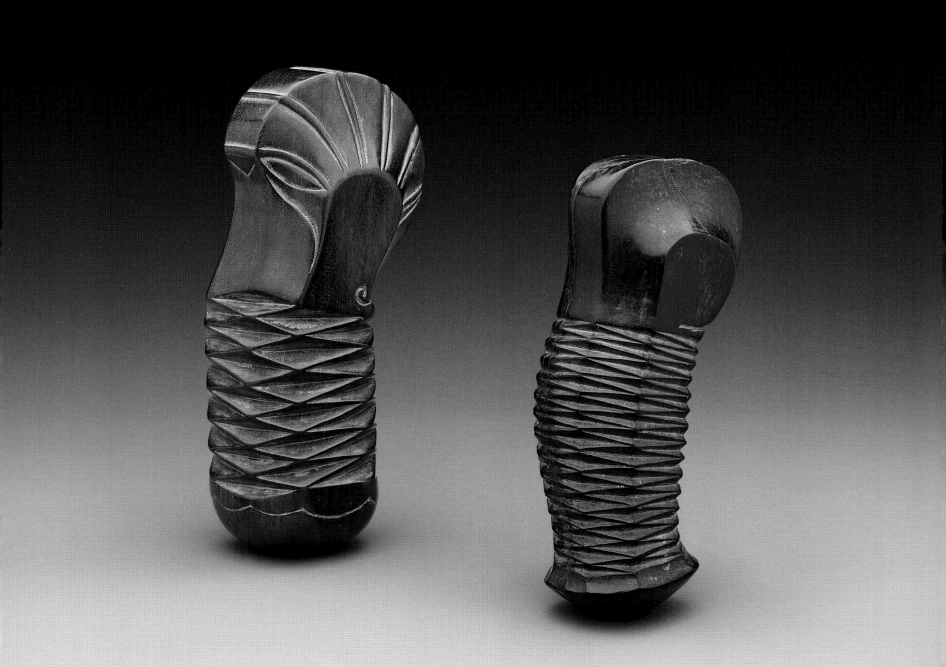

PAGE 53 >

HILT FROM SUMATRA (or Sumbawa?) | HILT FROM BALI
Wood
H. 10.5 cm | H. 10 cm

PAGES 54-55 >>

HILT FROM BALI | HILT FROM THE NORTH-EASTERN COAST OF JAVA OR EASTERN JAVA | HILT FROM EASTERN JAVA – Blambangan
Marine ivory – *Togogan* style | Marine ivory | Ivory
H. with base, 9.5 cm | H. 10 cm | H. 11 cm

Certain elements, such as the veiled face and the shape of the base, which is very similar to that of the Cecekan-style Bali hilts, suggest a Balinese veiled Durga, but the position of the legs and the right arm bent across the body to hold the "shawl" (or blanket) reaching up from halfway down the back, are rather unusual features in Bali and suggest the figure is a Sumatran work made in the *Jawa Demam* style. The head as a whole looks like a helmet, as in other veiled Durga-style hilts, and has two rounded protuberances on either side, which may be large earrings or a special kind of hairstyle. The usual *tumpal* appears in the center, between the barely outlined feet. The rhythm established by this series of tight and wide curves makes a seemingly very simple object interesting.

The extraordinary rotundities of this naked, ape-like, devilish figure all converge on the vortex created by the spiral on the belly, which is highlighted by the color, variety of tones and shine of the reddish wood, as well as the symbolism of the navel as the seat of vital energy. The spiral is taken up by the shoulders, at the sides near the legs and at the base of the back. The figure seems to be seated on large stones placed on a typical Balinese wooden base. This is an ancient hilt and objects of this kind are very rare. Fortunately, a subject of this kind does not lend itself to being forged as part of a kris aimed at the tourist market.

This fiendish being known as Nawasari has been carved in the *togogan* style, a favorite figure for hilts on krisses worn by the island's nobility and used to represent the gods, demons and heroes of Hindu-Balinese mythology [page 54 and 55, left].
Nawasari has big, bulging eyes, his mouth is set in a menacing, but at the same time laughing grimace, and his hair is arranged in radiating flames. His right hand is kept behind his back and holds the Nagapuspa (the sacred flower of Buddha and Shiva), or sometimes clutches ears of rice, while in his left he holds a fly whisk. The ancient, weathered ivory has acquired a typical amber hue. The carving is of the highest standard, and the figure must have been stunning when still adorned with precious stones set into the body and head, unfortunately now lost.

This demon with a diadem, bulbous eyes and projecting fangs is perhaps the great hero Bhima, as can be inferred from the two long fingernails, which are just visible [page 54 and 55, center]. The hairstyle is extremely elaborate and consists of a central bun and thick locks of hair combed upwards and ending in big curls. The furrowed brow is a very unusual feature, and gives the impression that the eyes have three eyebrows. The figure wears a magnificent breastplate, a belt with rosettes and a nine-petaled flower buckle on his loincloth. This exquisite seated figure leans slightly forwards and to the right, his right arm folded across his chest and the other held to his side. The central *tumpal* and those behind the figure are decorated with the classic C-shaped motif, like the diadem.

The bun on the head of this figure from the warrior caste [page 54 and 55, right] serves as a counterbalance for this significantly lopsided figure, lending it an unexpectedly ascetic appearance. The figure wears an elaborate necklace with symbols of the sun and the moon. One arm is held across his chest and he wears a fringed loincloth and sits on a throne made up of intricately carved triangular *tumpal* motifs. These perhaps symbolize the Tree of Life and are unusually also added around the head, setting off the hairstyle. The signs of wear, blemishes and patina on the ivory leave no doubt as to the antiquity of this splendid hilt fashioned in the Hindu-Javanese style.

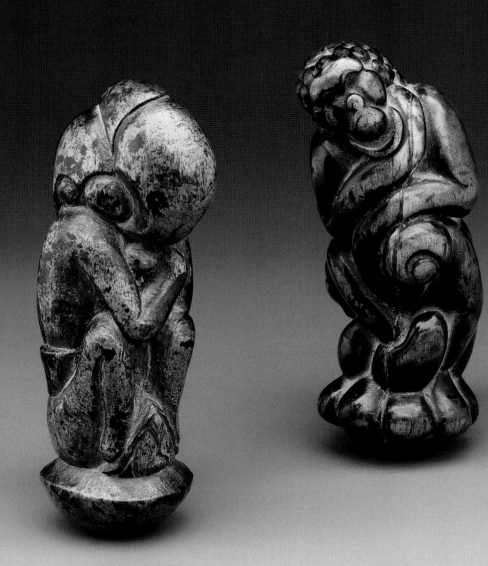

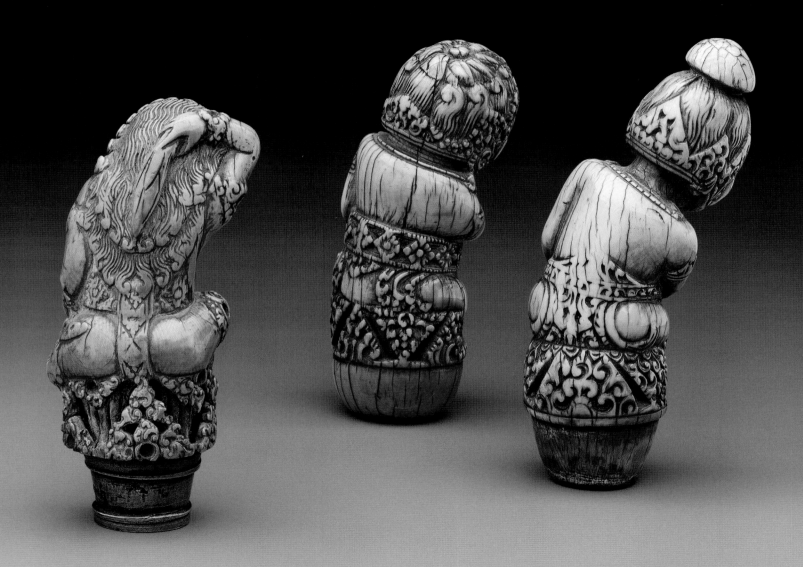

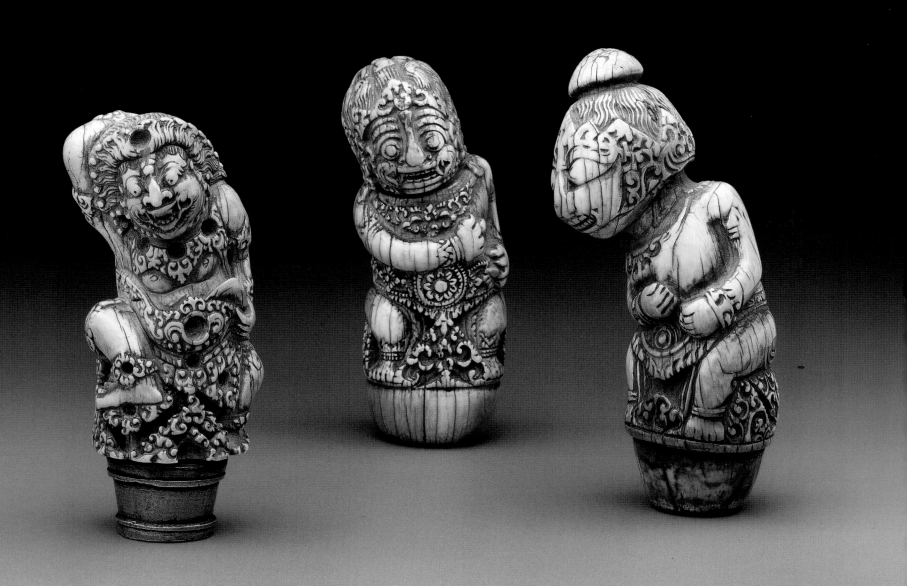

PAGE 57 >

HILT FROM WESTERN JAVA – Banten-Cirebon
Silver
H. 7.5 cm

This figure squats on a base with three rows of small semi-spirals. His hands are placed on his knees and his considerably inclined head features bulging eyes, a smile, a long mustache and curly hair. The figure wears an elaborate necklace, flaming bracelets, a flower on his belly and another splayed open to cover his genitals. All the foregoing are typical features of a classic demon as depicted on the north-western coast of Java, which is famous for this kind of hilt.

PAGES 58-59 >>

HILT FROM EASTERN JAVA
Whale bone
H. 10.5 cm

The artist has managed with only three basic elements to give this indefinable creature a fiendish and ghostly appearance: flashing fangs, small eyes set close together, and the choice of whale bone as the material from which the hilt is carved. This terrifying being is seated on a traditional throne composed of triangles, with the sun and moon depicted on its chest. Poking out from under the long, flowing hairstyle, itself a sign of magic powers, is the beak of Garuda, the majestic bird of Hindu and Buddhist mythology, protecting the figure from any sudden attack from behind. The turquoise in its cheek and rubies in the ears seem to underline this sinister figure's only point of contact with the world of men. Although it is without feet, the creature appears ready to follow the baleful hordes that inhabit places of burial and cremation. The condition of the whale bone, and the characteristics of the subject of the hilt, confirm the great age of this invaluable object.

PAGES 60-61 >>>

HILT FROM EASTERN JAVA (or BALI?)
Stone
H. 10.5 cm

The two fang-like teeth, a broad nose and half-open mouth are signs that the figure is a demon; the empty eye-sockets (owing to the missing gems) make this swollen-bellied Nawasari a particularly terrifying creature. The demon wears a loincloth hanging down to the ground and hiding its genitals. Its hand rests on its side, while the other is behind its back where it holds Shiva's flower, as if reluctant to break the flow of smooth curves which are the chief merit of this stone sculpture, corroded, worn and very ancient as it is. Small precious stones are still set in the round band at the base and this is the feature which suggests the piece comes from Bali.

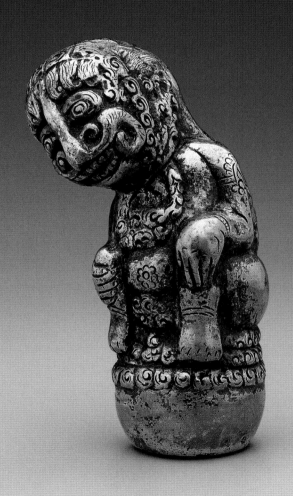

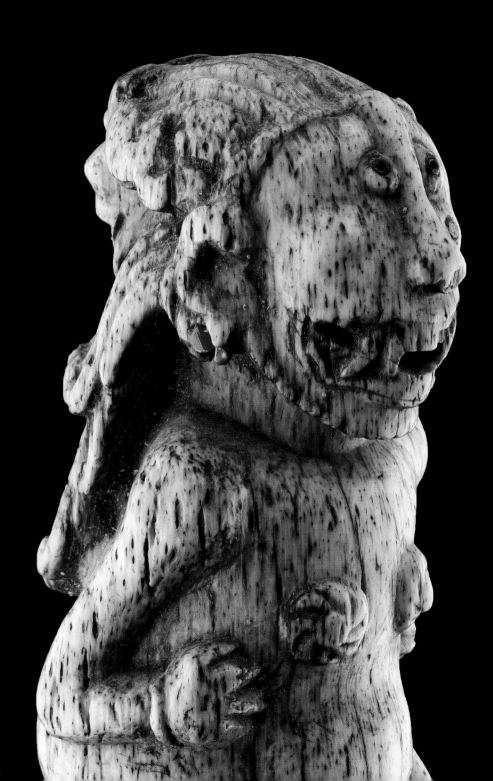

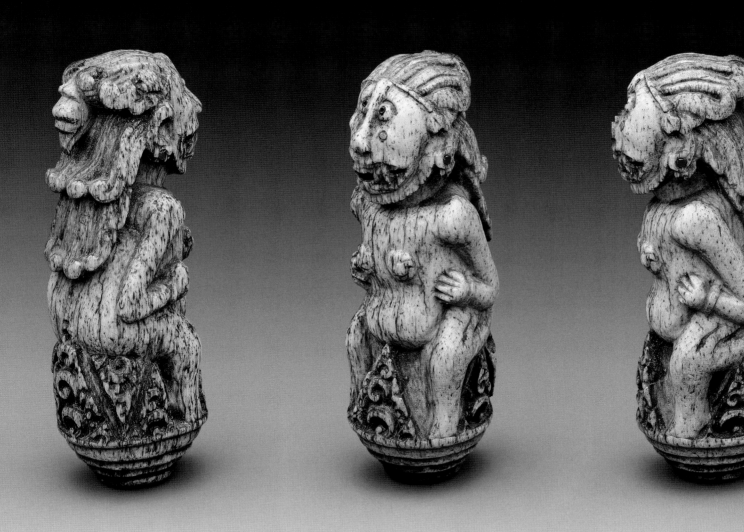

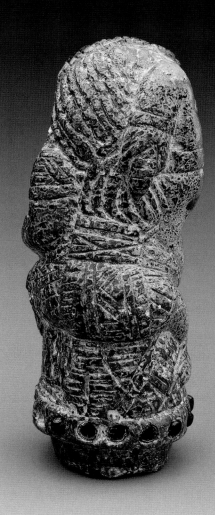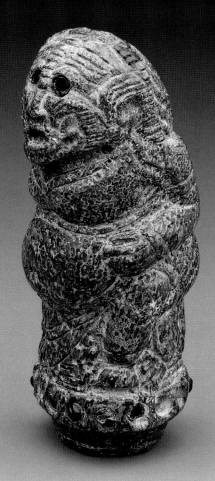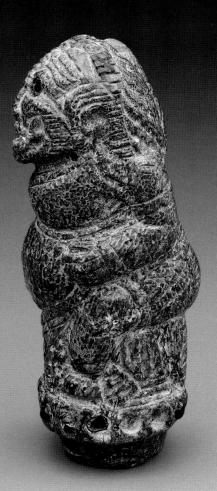

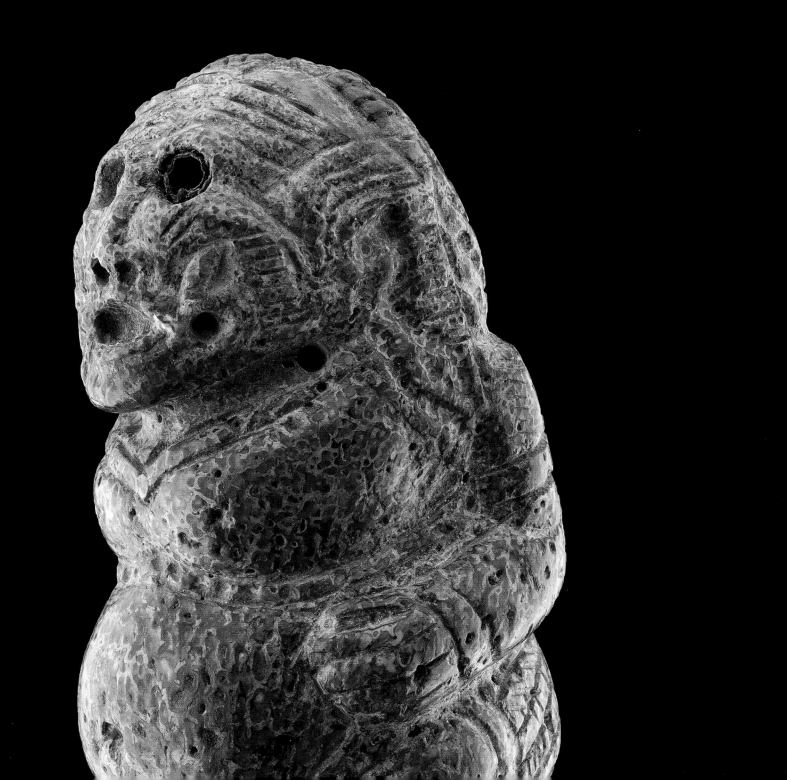

PAGE 63 >
HILT FROM WESTERN JAVA – Cirebon (?)
Limestone
H. 8.3 cm

It is difficult to identify the provenance of this very ancient stone hilt depicting the Hindu god Ganesha, son of Shiva. Stone is a material very rarely found in hilts and makes this particular specimen extremely special. The figure wears a headdress decorated with triangles, as if the artist wanted to make up for the absence of *tumpal* motifs at the base. The deity has four arms and in his top right hand he holds his favorite sweet, *modak*, as he sits in meditation. In contrast to the normal iconography, this figure is rather slim, and the highly emphasized navel on the belly immediately stands out.

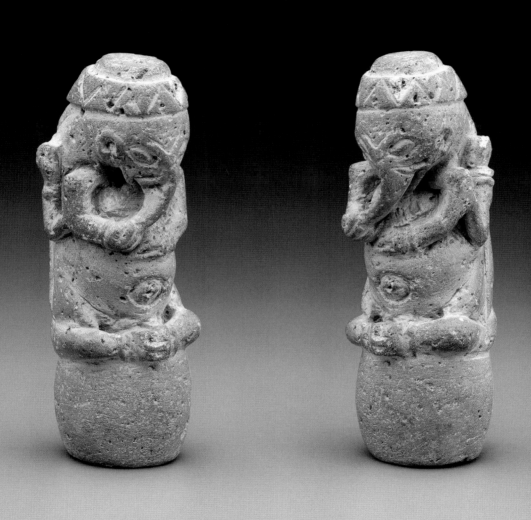

PAGES 65-67 >

HILT FROM THE MALAY PENINSULA

Sperm whale tooth ivory – *Pangulu* style

H. 6 cm

This Bugis-influenced hilt plays on the rhythm between the skillfully and very tastefully arranged smooth and engraved areas. The artist has exploited the "stain" that appears on sperm-whale ivory to outline the head-beak section and tiny eyes, to great effect. The feathers have been rendered in two different ways—with little, almost filigree dots on the body and with densely clustered small eyelets on the base. This bird's breast boasts a large eight-petaled flower and above the throat feathers is the lower portion of the curved beak. This is an outstanding specimen of its kind.

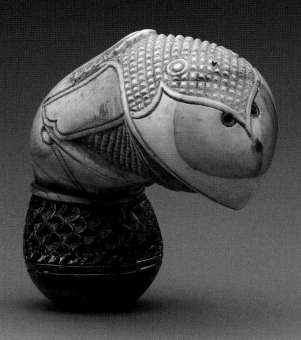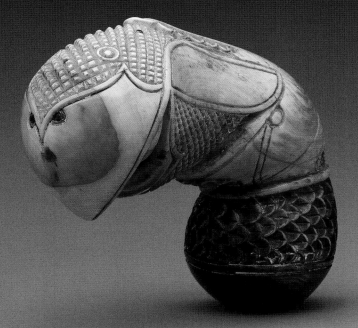

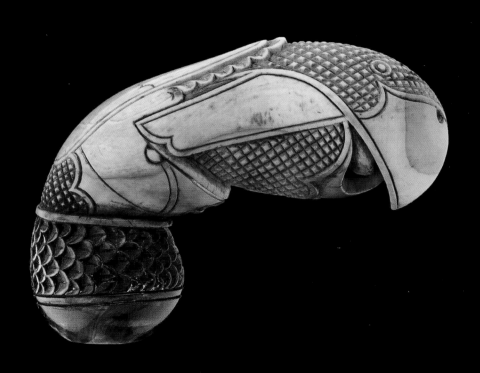

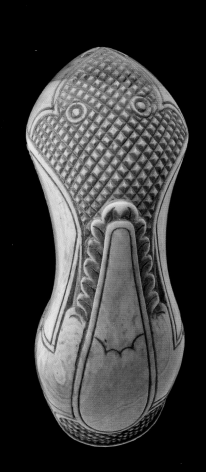

PAGES 69-71>

HILTS FROM WESTERN JAVA

Elephant ivory | Ebony

H. 10 cm | H. 10 cm

The first of these hilts [page 71, left] is a very special one because at first sight it may appear to be in the Nyamba style, but it actually depicts Bhima wearing a necklace of snakes and long thumbnails. On his head is a diadem, which serves to hold in place the shock of curly hair flowing down to the figure's waist, indicating that he is a prince. On the nape of his neck can be seen the beak of Garuda [page 70], whose job is to protect his rear. His grimace is accentuated by the long, thick mustache on the sides of his face. The hairstyle is worthy of a true Indonesian artist.

Experts are not unanimous in identifying the figure as Bhima, some books continuing to describe the effigy as simply a "demon", although the identification is now quite commonly accepted.

The second hilt, made of ebony, is Raden Bhima, Prince Bhima, and his status is proclaimed by the crown on his head and the jewels festooning his ears [page 71, right]. The luxuriant mustache, beard, eyebrows and long hair are all curly and as usual the figure's hands rest on his knees and his feet are on a *tumpal*. Bhima was famous for his great size and strength and his favorite weapon in battle was the mace.

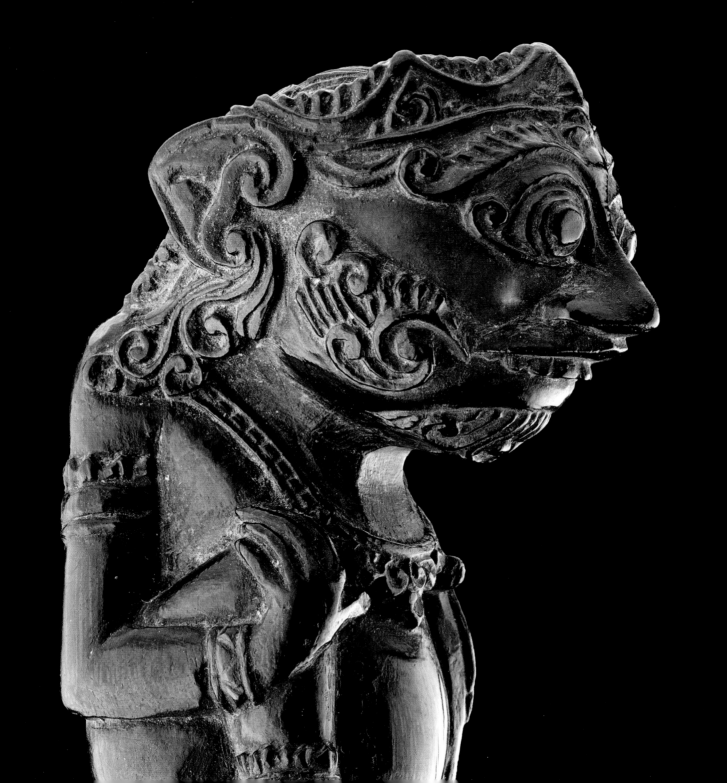

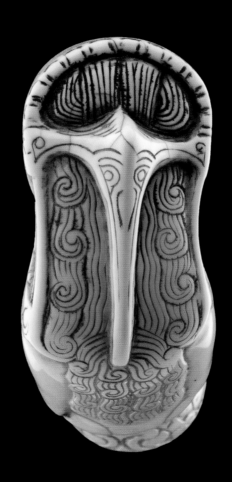

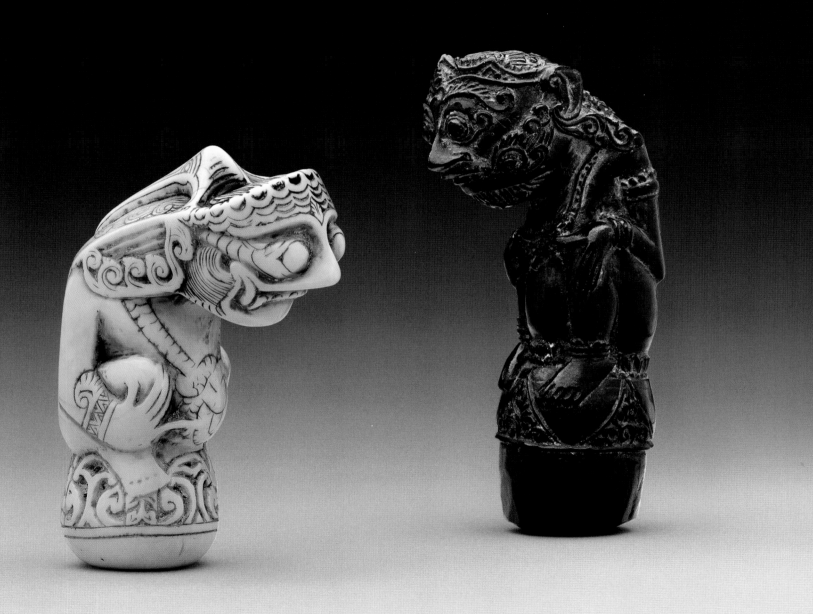

PAGES 73-75 >

TAJONG KRIS HILT, also known as Pekaka, Pattani or Kingfisher kris – Malay Peninsula, Kelantan area
HILT FROM JAVA – Tegal

Kemuning (*Murraya paniculata*) or *kenaung* (*Dyospiros ebenum*) wood | Wood
H. 10 cm | H. 13 cm

This type of hilt [page 73, left] comes from the Malaysian regions of Kelantan or Terengganu and especially the border province of Pattani, which is at present in Thailand. It is used for the Tajong kris, a warrior's kris which is often part of the regalia of almost all the Malaysian royal families.

The name kingfisher, by which it is commonly known nowadays, is only a conventional name since the figure might actually be derived from the Wayang Kulit shadow theater, and some experts believe it may depict the Hindu god Shiva.

The nose is smooth and upturned [page 75, detail] and the figure's cheeks are decorated with engraved geometric patterns, while scrolls and floral motifs adorn the body. The pyramid on the figure's back represents Garuda's beak and two scrolls on the forehead symbolize the hands held in a position of meditation. The fretwork crest and beard lend the head of the hilt a square, aggressive air.

This fierce-looking figure [page 74] with exuberant mustache represents Dursasana, as he appears in the Wayang. Dursasana is a member of the Kaurava clan in the Mahabharata, where he is a formidable, though coarse and cruel warrior and is finally killed by Bhima. He is also known as Rajamala—the name he is given in his guise as a victorious fighter. Kris with this type of hilt are often used by court jesters. The object's size is unusual: 13 cm high x 9 cm wide (a normal hilt is 8–9 cm high), and the carved decorations are proportionately large. Judging by the long thumbnails and crown, it is tempting to think this is a representation of the usual Bhima/ancestor or Garuda figure found on Cirebon hilts, except on a larger scale. But the truth is this type of speculation is typical of the mystery surrounding the meaning of many hilts, long since lost in the mists of time.

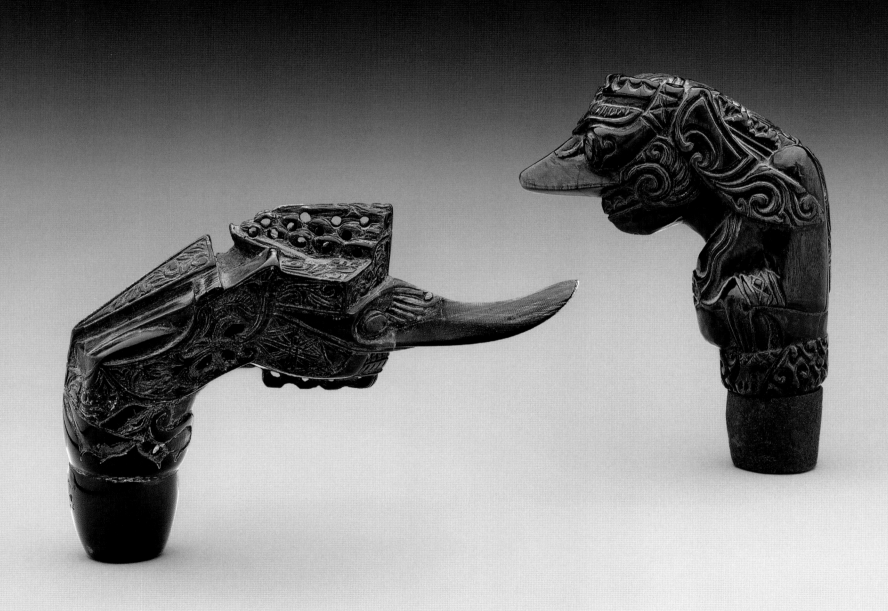

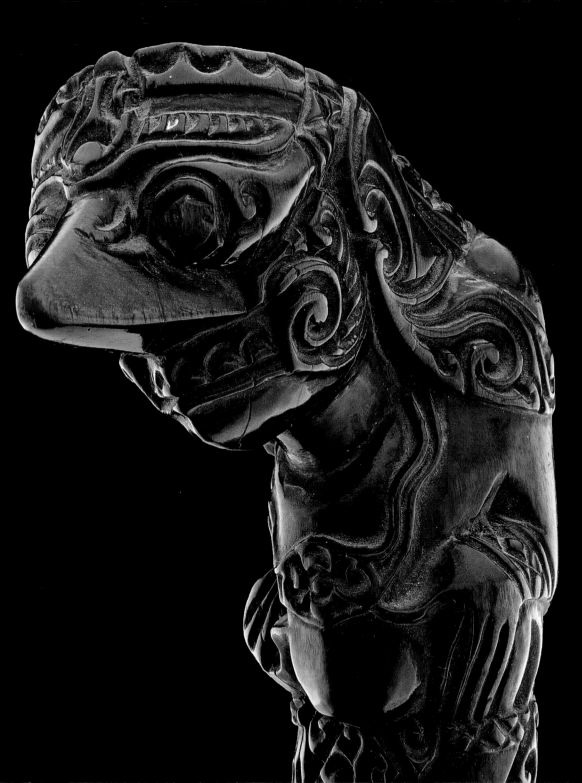

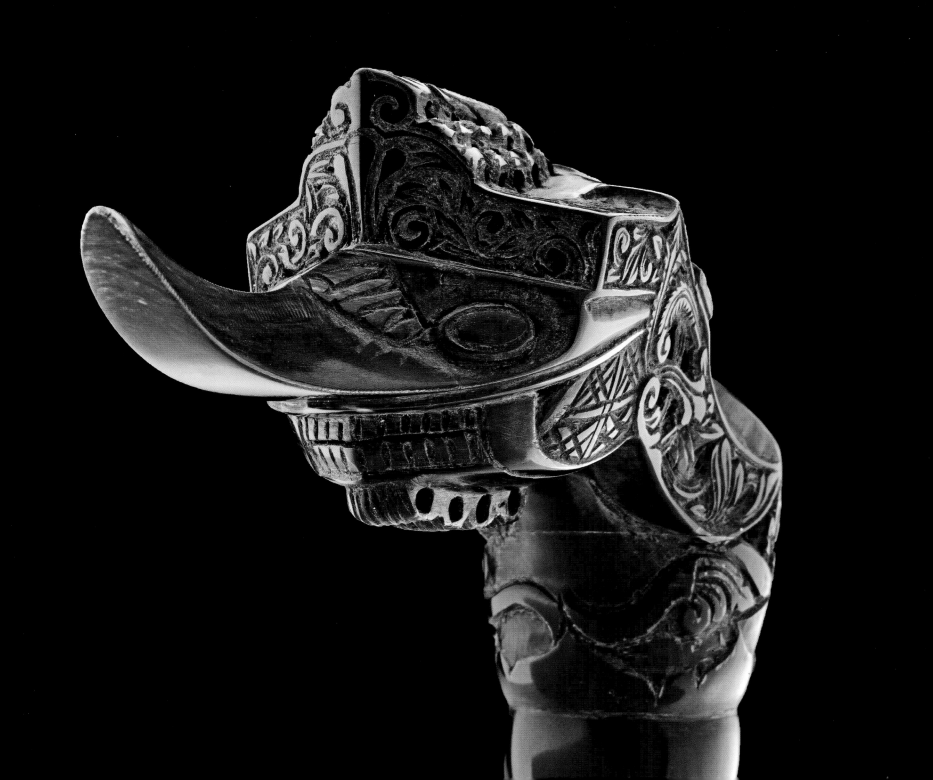

PAGE 77 >
NYAMBA HILT – Eastern Java
Silver alloy
H. 10.5 cm

The iconography of Nyamba, a figure in the Wayang, goes back to the Hindu kingdom of Majapahit (ca. 1293–1500), a powerful empire in the eastern part of central Java, and is distinguished by two classic features, the prominent nose and the crown, *mahkota*. This particular specimen has a large jewel made up of four lobes of different sized petals on its chest similar to the one in the center of the crown. The figure's dress has a central pattern composed of intersecting lines forming four triangles, and the belt shares the same motif, in this case producing a tiny checked pattern. The feet and shoulders are decorated with oval motifs with filigree edging. The hands are placed on the knees, one holding the knee itself, and the other simply resting on it. The Garuda head on the nape of the neck is huge, with clearly outlined eyes and a large beak displaying all the teeth and fangs. Large leaves adorn the lower part of the body and the rounded base.
It is worth noting this hilt's expressiveness, revealed best when seen in profile, the result of a skillful and surprising play of points, swells and hollows.

PAGES 78-79 >>
HILT FROM MADURA
Marine ivory – *Janggelan* style
H. 9.3 cm

The *Janggelan* style is typical of Madura, but it is also used in north-eastern Java. It takes the form of a pine cone or corn cob, and the decoration is exclusively floral or semi-figurative, as can be seen in this hilt covered with a leaf and double-corolla flower pattern. Two bird-heads enliven the composition, one peeping out from some fretwork carving at the top of the pine cone, and the other emerging from heavily indented leaves just below. The beautiful reverse features two crouching eagles (although the treatment of the feathers makes them look like snakes with a magic eagle's head!), the face of an imp or sprite, a horse's muzzle, and vegetation and flowers, as on the front.

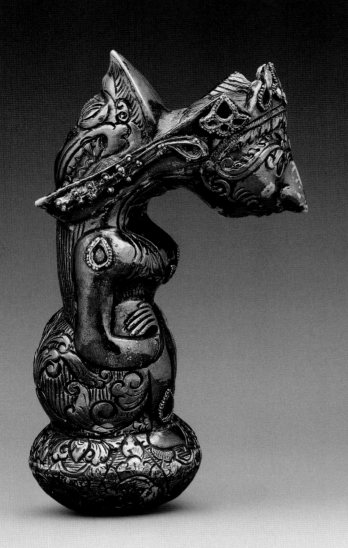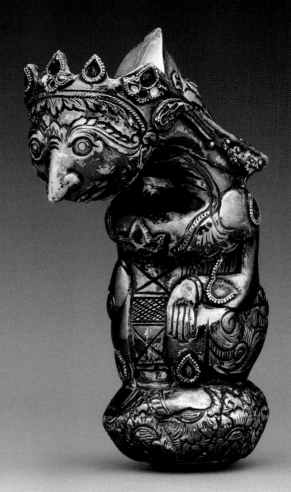

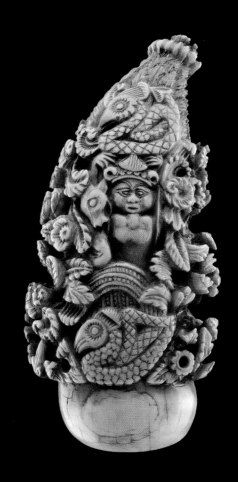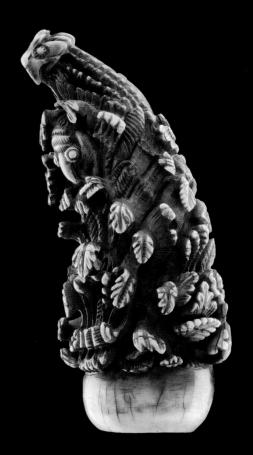

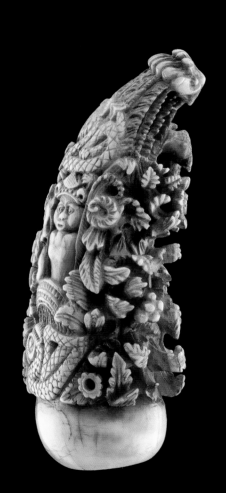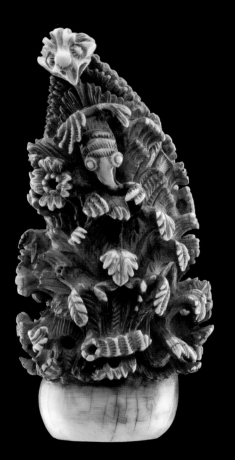

PAGES 81-83 >

BUGI HILTS – South-western Sulawesi

Marine ivory – Pangulu style
H. 5 to 6 cm

The Bugi, or Bugis, of Sulawesi (Celebes) were seafarers, traders and warriors, but also great wood-carvers and sculptors, as can be seen from these splendid pistol hilts. They represent a bird, depicted either as Garuda in flight or as a member of a species of long-necked marine bird well known to the Bugi. It is worth drawing attention to the hilt in the center, which like the others is exquisitely decorated with carvings of tendrils interlaced with flowers, rows of rosettes on the head and concentric circles with a central rosette on the back. This piece stands out from the other specimens owing to the large cornelian set into the base and the Solomon's Seal on the breast, details which serve to further embellish the object. Solomon's Seal is a six-pointed star made up of two entwined triangles. It is also part of the symbolism of Islam, where it has assumed a magical and therapeutic status.

PAGES 84-87 >>>

HILTS FROM MADURA

Donoriko style | *Donoriko* style | *Donoriko* style | *Donoriko* style
H. 10 cm | H. 9 cm | H. 9 cm | H. 9 cm

The *Donoriko* style, which is typical of many Madura hilts, is characterized by a massive upper section, the so-called head, which is rounded and bent forward, with two protuberances at the sides that look like ears. An array of floral and/or semi-figurative motifs decorate the rest of the figure.

These hilts are perfectly in line with the canons of the style, but the first example on the left, made of bone, displays two original features: the head has eyes and two leaves project from the forehead to form horns. The rest of the figure has double garlands of palmettes fastened at the top by a flower and an openwork neck. On the chest is the image of an eagle with splayed wings. Generally speaking, in profile the figure looks like a horse with a mane rendered with deeply carved transverse striations.

The second figure on the left is made of ivory and exhibits a truly extraordinary range of decorative motifs: ten-petaled flowers and festoons encircle the base, a large sun with twelve rays surmounted by a flower and surrounded by leaves and flowers adorn the figure's back, while the front exhibits the mythical winged horse Kuda Semberani, which recurs in Madura hilts and in the coat-of-arms of the Sultan of Sumenep (eastern part of the island). The top section bends sharply downwards, and has the two lateral protuberances made up of flowers that are typical of this style. Once again the "neck" section is decorated with openwork carving.

The next hilt is made of marine ivory and has acquired an orange tinge. Its chief features are the two angels or two *kinnaras* with extremely long wings carved on horseback on either side of the body; *kinnaras* are mythological creatures, half man, half bird.

The last hilt on the right is fashioned from ivory and has a large eagle on its breast. This is the specimen which best typifies the Madura floral style *gaya kembang*, also known as the ginger-flower style, *kembang temu*.

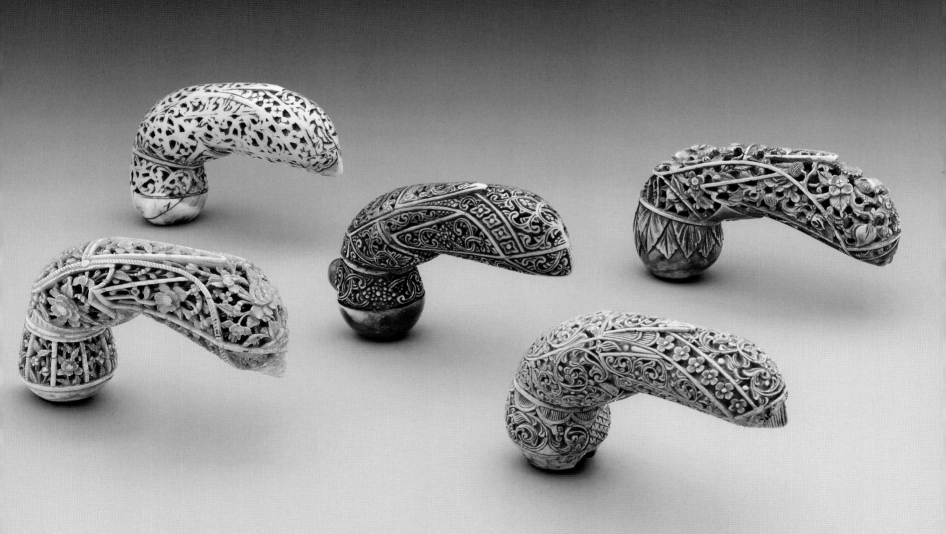

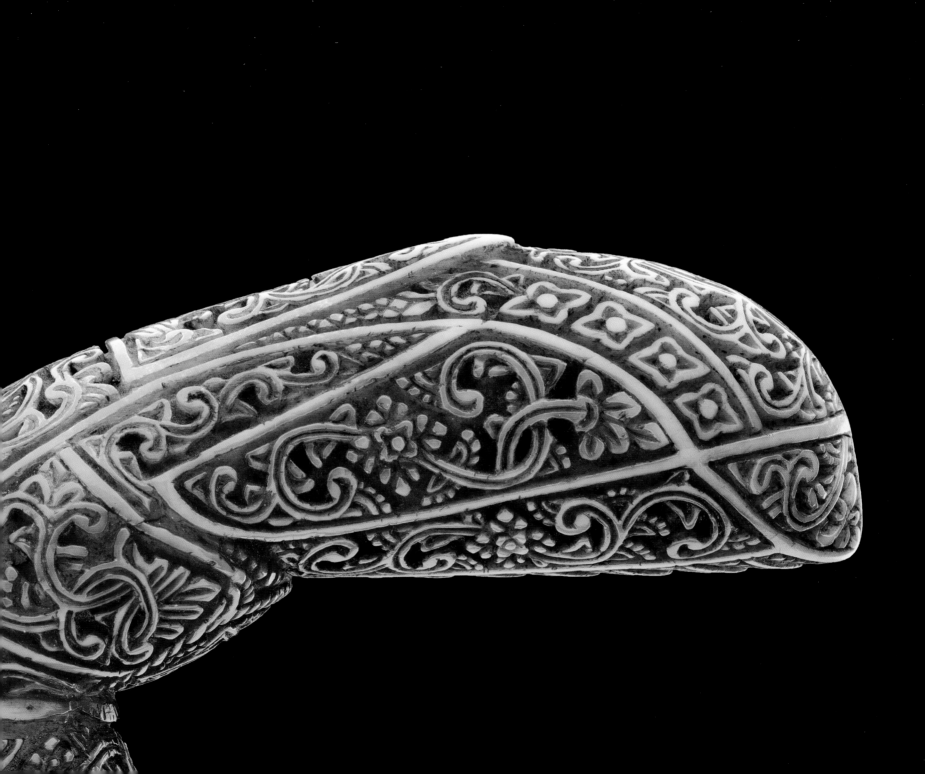

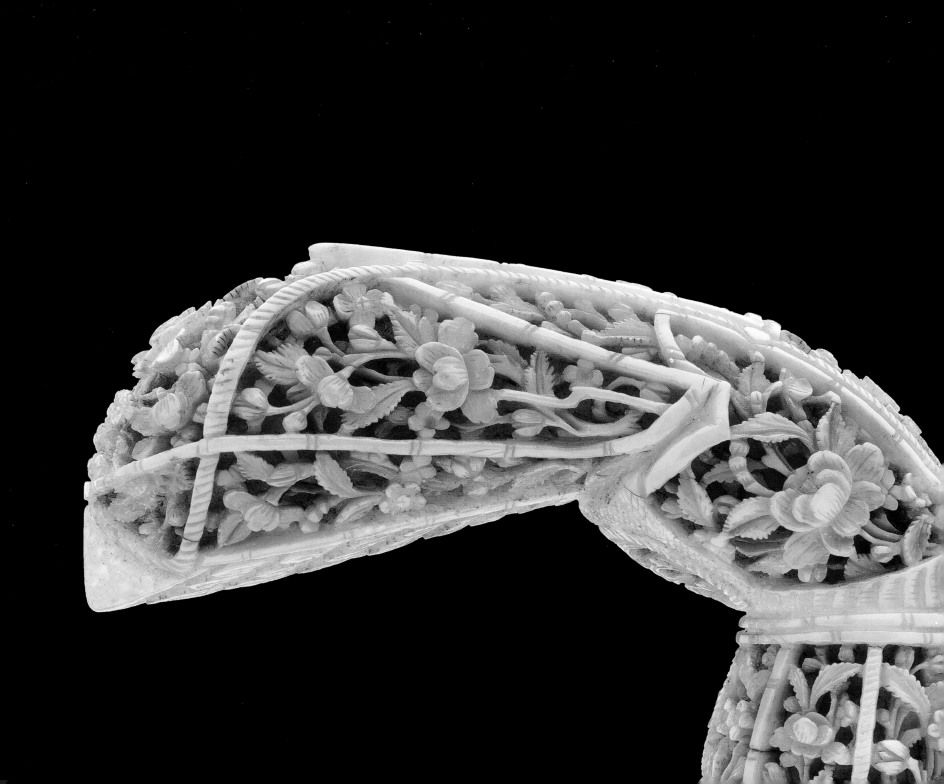

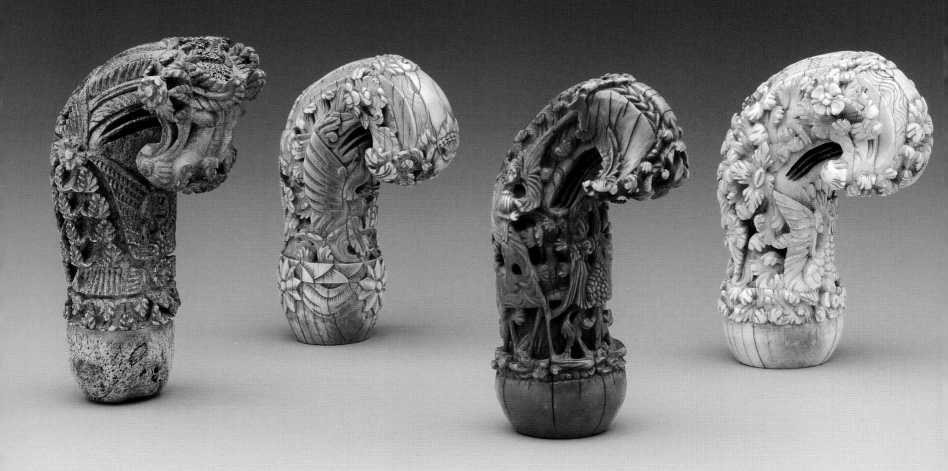

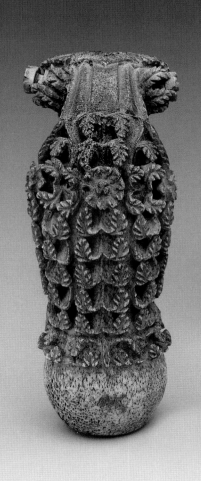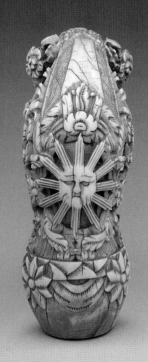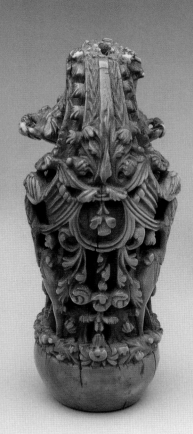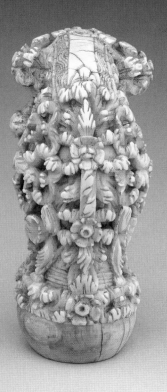

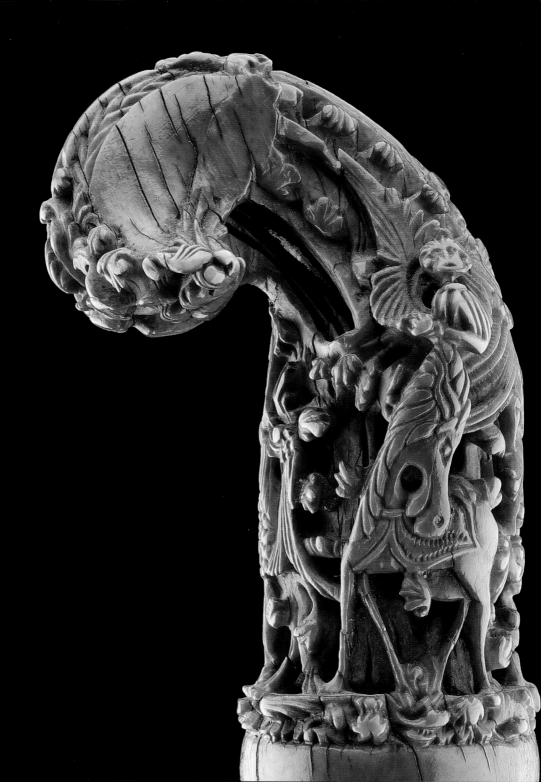

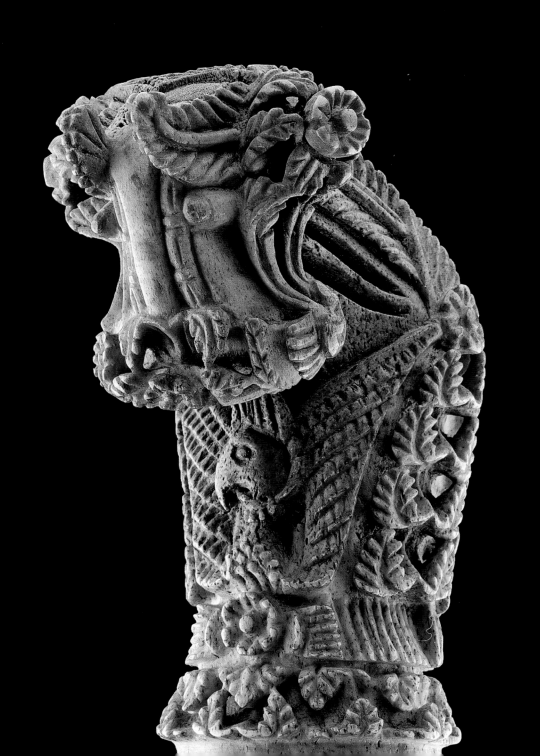

PAGES 89-91 >

HILTS FROM BALI

Sonokeling Rosewood (*Dalbergia Latifolia*) – ebony or Areng wood – veiled Durga style | Sonokeling Rosewood (*Dalbergia Latifolia*) – ebony or Areng wood – veiled Durga style | Areng wood – *Kocet-Kocetan* style – southern Bali | Areng wood – *Kocet-Kocetan* style – southern Bali
H. 12 cm | 10.5 cm | 10 cm | 12.3 cm

Two different ways of depicting the terrible goddess Durga, in the materials used and in the sensibility displayed compared with the veiled Durga of Sumatra.

In the ebony hilt, second from the left, the goddess appears dressed as a warrior. As usual, her face is covered—in this case by a cloth, which takes the form of a helmet. She wears a breastplate and a beautiful belt, formed by two snakes rippling a long way down her legs and facing each other at the waist. In her capacity as Shiva's consort, Durga has a deadly long fingernail on each hand. A large *tumpal* is carved on the front, with its tip rising up between the two snakes, while those on the sides and back are smaller.

In the first hilt on the left, made of sonokeling wood, Durga the unapproachable is depicted in a different manner but still has her face covered with a veil, the tip of which can be seen at the front. There are two snakes by the small central *tumpal* and two more by the side of the large *tumpal* at the back, which also has the so-called "burning eye of the sun", the definition adopted to make it easier to understand this type of decoration, which is very common in Indonesia and in kris ornamentation.

There are traces of red and gilding throughout the figure.

Exactly what two-winged, six-limbed insect this hilt is meant to represent is a real enigma. The possibilities range from the beetle and the praying mantis, to a creature with an anthropomorphic or horse-like head, or a figure from Balinese mythology. Indeed, it is sometimes compared to Batara Karpa, the sacred scarab son of the great ascetic Kasyapa, symbolized by the tortoise, and Dewi Vinata, the demon bird.

The sculpture perfectly conveys the shape of an insect placed on the circular base imitating the cabochon-cut stones often found on Bali hilts. Kris with *Kocet-Kocetan* used to be the strict preserve of Hindu priests, religious leaders or, it seems, even the authorities of the ancient principalities of southern Bali.

The front of the other *Kocet kocetan* hilt, carved from the same wood, is formed by a *tumpal* at the base and two triangles on the chest with the point facing down, which are completely smooth and shiny, displaying the full beauty of the wood. The feet are clearly visible between the triangles. Each side is formed by a wing and two small *tumpal* motifs, the top is made up of a large *tumpal* and three lozenges, one of which is on the head. The lozenge is a very common decorative motif in Indonesia.

It is impossible not to remark on the "play of angles" around the head.

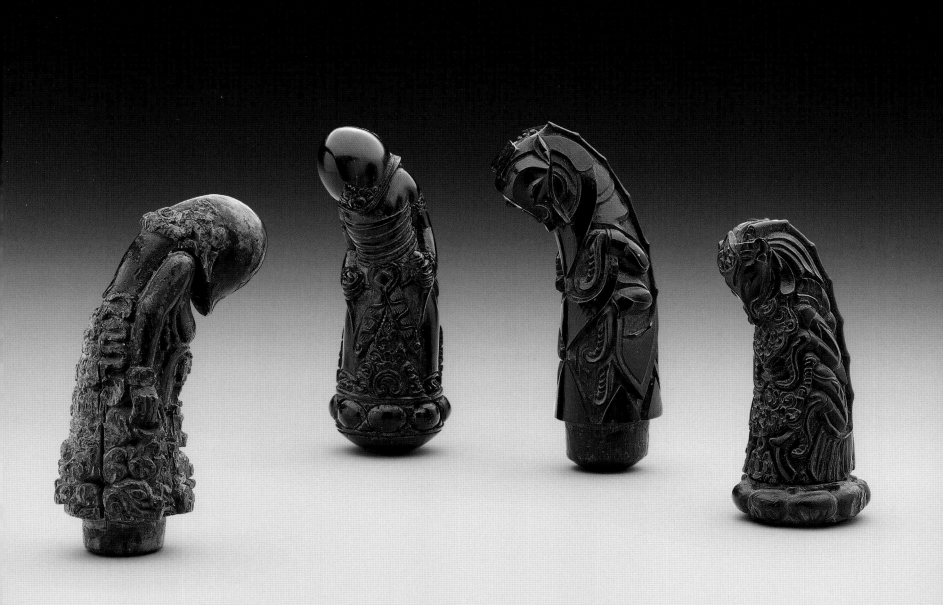

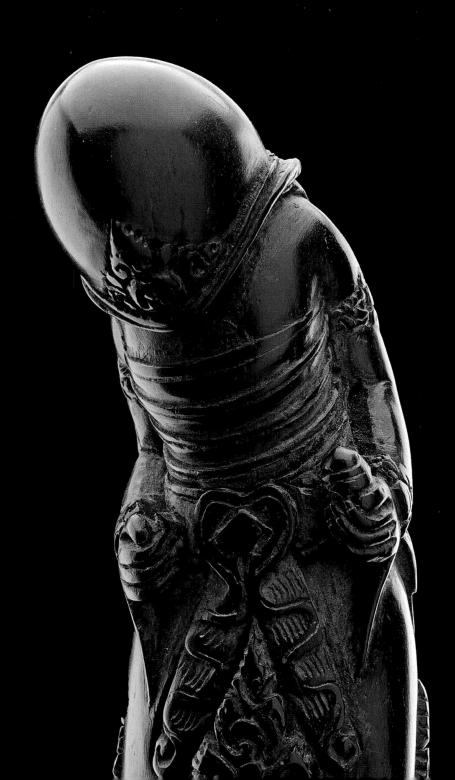

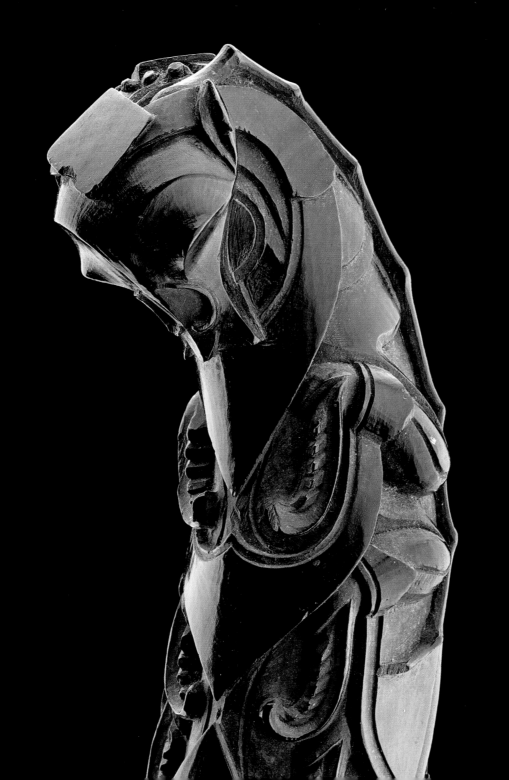

PAGE 93 >
HILT FROM BALI
Wood
H. 10 cm

This figure stands between two *tumpal* motifs composed of leaves and flowers. The left hand is hanging loosely at the side of the body, while the right holds a stick. The figure wears a short sarong with a rather heavy belt and two wide braces behind. The rear of the figure displays two rather interesting features: the kris slipped under the belt, and an unusual hairstyle, in which the head is shaved to halfway down the back of the head, below this is a vertical parting and the long hair on either side is combed forwards, ending in little curls. A flaming third eye is set between the eyebrows. In all likelihood, the figure depicted is a Pedanda—a high-ranking Brahmin priest or a sage. The figure looks like a portrait. The way he carries the kris is rather unusual, since it is worn higher in Bali, and is in fact closer to the Javanese manner. This is an extremely interesting hilt.

PAGES 94-95 >>
GANA HILT – Sumatra | HILT FROM SOUTHERN SUMATRA
Ivory – probably walrus tusk | Black buffalo horn
H. 7 cm | A small hilt, 7 x 2 cm

An ability to bring out the strange zoomorphic or anthropomorphic shapes which are suggested by the shape or grain of wood, marine animal teeth, horns, mother-of-pearl, coral, black coral and many other materials, is characteristic of Malay craftsmen and the art of the whole Indonesian Archipelago.
These forms, known as *gana*, are considered to be self-manifesting and endow kris hilts with magical and talismanic powers. The ivory of this figure has a veined pattern on the back, an orange patch on the head and shoulder, and a pale green tinge on the base.

The interlaced pattern in the base seems even exaggeratedly intricate in such a slippery black figure, but it does bring the object down to a less fantastic dimension. Knowing how to turn an abstract design on its head with a simple touch is a great prerogative of Indonesian artists. In spite of the strange shape, which might be described as almost-*gana* in view of the natural protuberances in the head, this bird-like figure actually respects the canons of the style and is depicted in the classic squatting posture.

PAGES 96-97 >>>
HILT FROM MADURA/PASISIR JAVA | HILT FROM THE NORTHERN COAST OF JAVA
Bone | Ebony
H. 10 cm | H. 10 cm

Although the first hilt [page 97, right] is highly stylized, the features are nonetheless clear and well outlined: the hairstyle with three bands of curls spreading out from a ten-petaled flower on the forehead [page 96], the braid on the base, the endless knot, a common motif in Islamic art and suggesting the area of provenance, the central beak and six legs, four of which emerging from the U-shaped swirls on the chest and two jutting out from overlapping feathered wings at the base. All these features make this a rare specimen and a real enigma: is this a concealed figure, as suggested by the hair; or a half-bird, as suggested by the beak; or half a six-legged winged insect, like a Balinese *kocet-kocetan*?

This demon figure [page 97, left] with barely outlined features looks as though it is wearing its own hair wrapped around it in a spiral. Only a part of the right arm and an unidentifiable object on the shoulder are visible. The dark color of the ebony makes this figure all the more mysterious, as it seems to attempt to hide away from the world around it, creating a defensive barrier with its long hair, symbolizing asceticism.

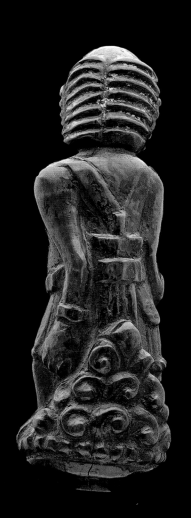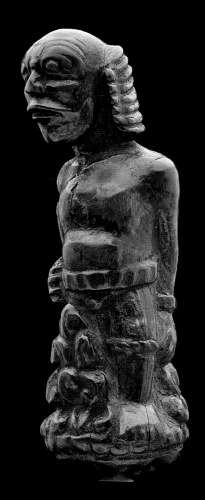

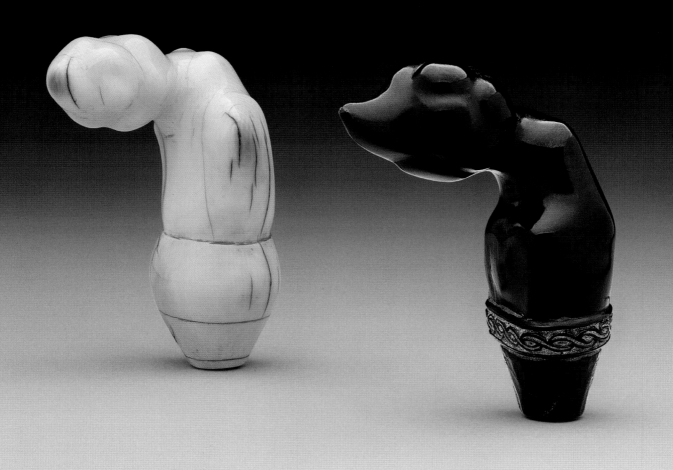

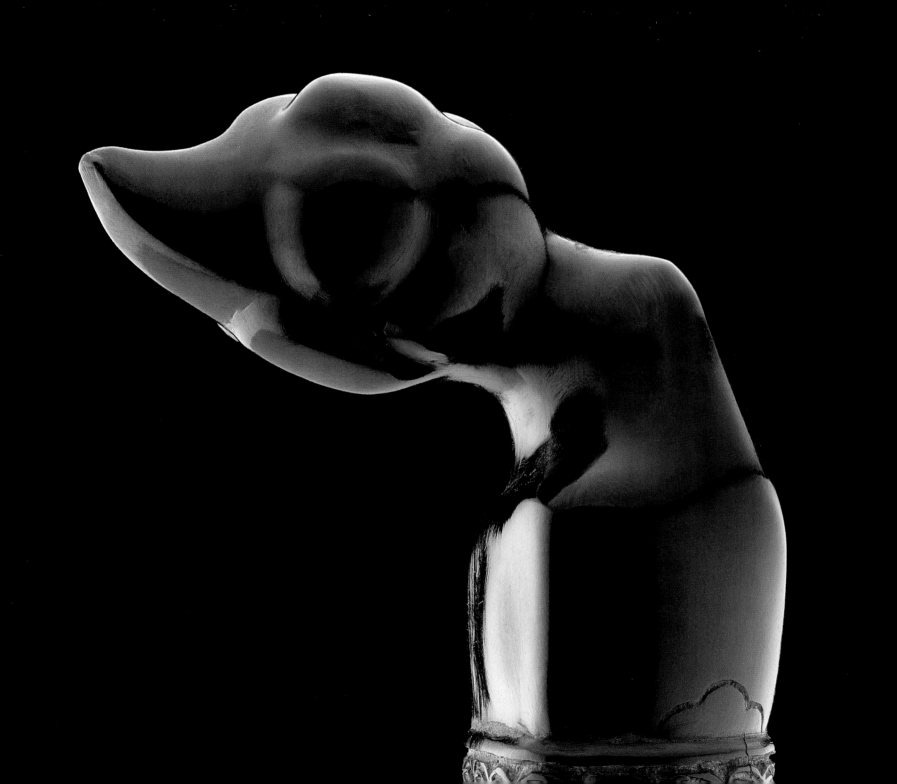

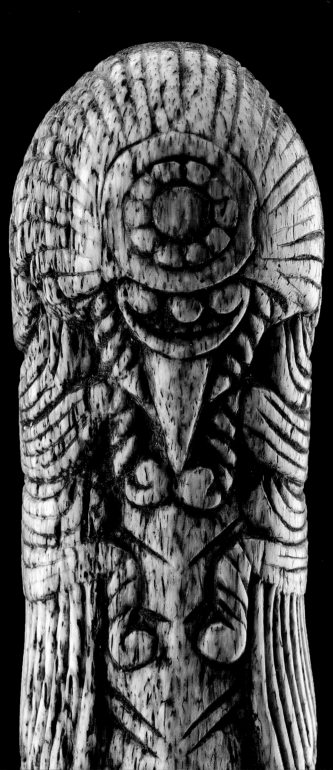

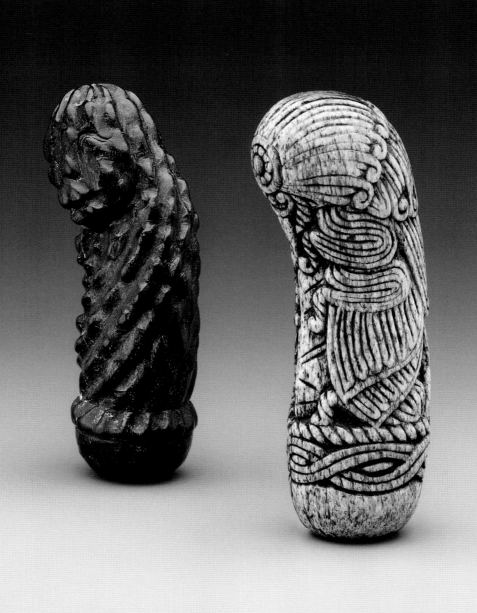

PAGES 99-101 >

HILT FROM WESTERN JAVA? | HILTS FROM SUMATRA

Ivory | Ivory – *Jawa Demam* style

H. 6.5 cm | H. 7.5 cm | H. 6 cm

The first figure [left] is not disguised and indistinct as usual; the limbs are well outlined, as are the hairstyle, with a double curl at the neck, and the spiral eyes, which was the way they were depicted at the time of the Majapahit Empire.

On the figure's head is a flower with a double corolla, while a leaf jewel adorns each ear. The base has the classic *tumpal* with a C-shaped decoration and scrolls. From the aesthetic point of view, the important and surprising thing about this hilt is the exaggerated inclination of the head, counterbalanced by the position of the arms, which continue the arc and describe a semicircle.

The right arm of the other two figures [center and right] is in full view and the hand, not actually visible, holds a "shawl" (or blanket), as is typical of this style. On the base of the central figure are large lotus flowers, and an interlaced pattern in the middle of its head is flanked by two striped bands, while the figure on the right is seated on triangles decorated with scrollwork and open flowers, as are the body and head. Both are deeply carved with the greatest skill.

PAGES 102-103 >

HILTS FROM MADURA

Marine ivory – *Donoriko* style – *Tumenggunan* (Regent) style – *Kojuk mrenges*

(bucktoothed smiling bird) style

H. from 8 to 10 cm

The hilts at the front (*Donoriko* and *Tumengguan*) display the classic symbols of Madura: the winged horse, the crowned lion flanked by two horses, the eagle, the sun, the crown and wings, all encircled by flowers and leaves. The lion and crown allude to the Dutch royal house of Orange-Nassau. The two hilts in the second row (*Kojuk Mrenges*) are particularly interesting for the symbolism of their decorations: the Dutch crown, a tiny demon mask under the crown itself, eagles, a lion's head, Dutch epaulettes on the back and a winged horse and dragon on the sides. All six hilts provide clear evidence of the renowned carving and engraving skills of Madura artists, who are noted for the painstaking precision of their elaborate decorations.

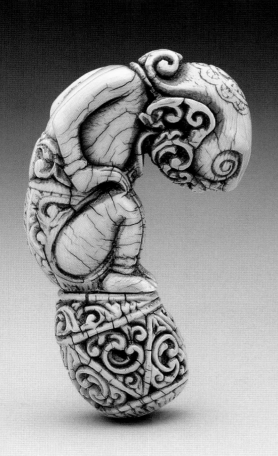
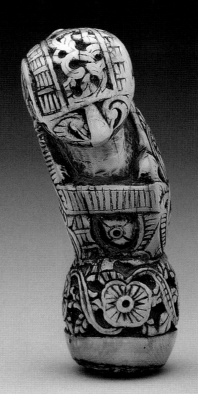
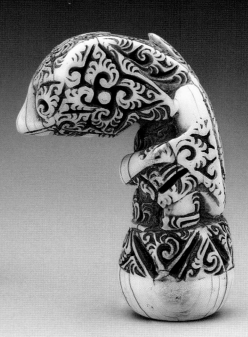

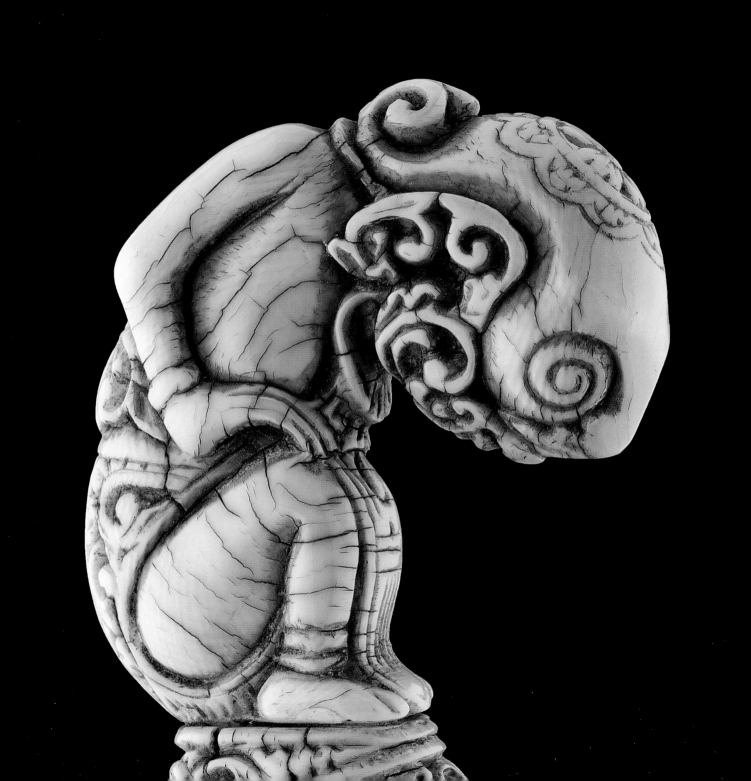

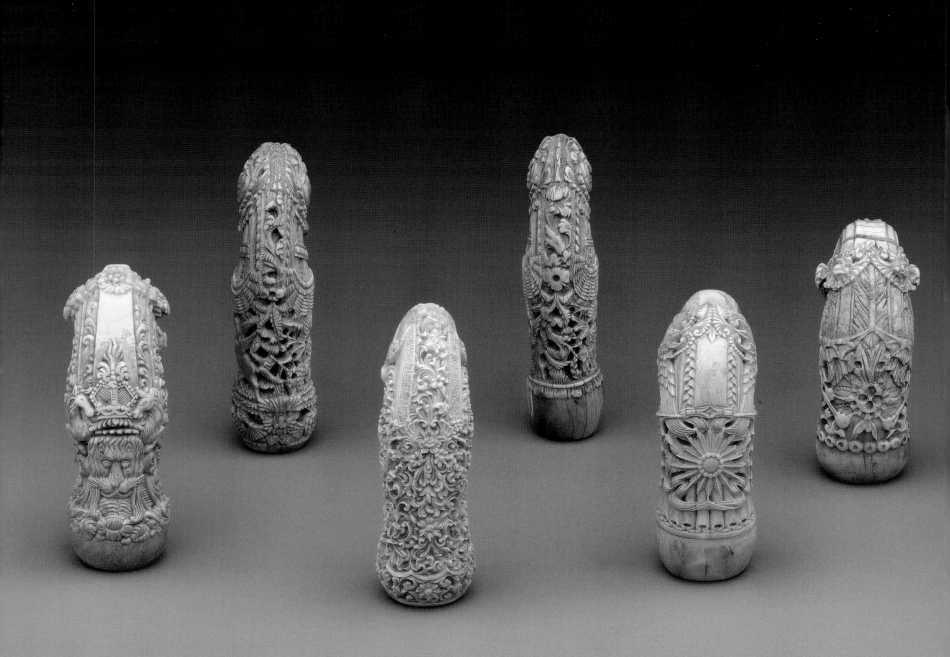

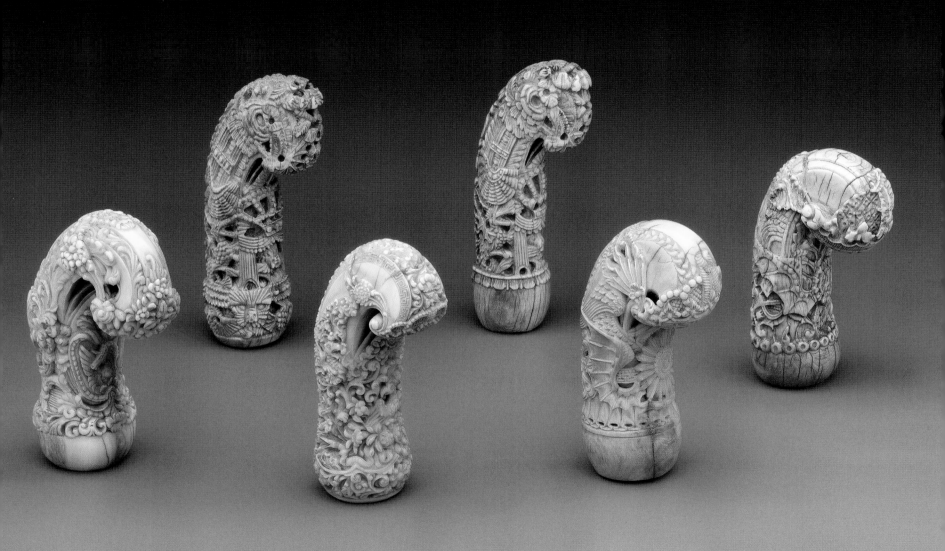

HILTS FROM SOUTHERN SUMATRA – Palembang area
Wood and gold – *Jawa Demam* style
H. 9 cm | H. 8 cm

The wooden decoration covering the whole object is based on a beautiful and deeply engraved scroll and flaming curl motif. A flame is carved on the small crest on the back and the legs have two curls instead of feet. The figure's right elbow rests on its knee, and it holds a "shawl". But in the final analysis it is the base that attracts the eye, with its golden triangles with engraved leaves and flowers, punctuated and enlivened by small trilobed palmettes placed exactly over the double wooden triangles of the base. The part beneath rests on trilobed leaves that splay outwards from the cylindrical opening housing the blade, and are identical to the palmettes.

This object is in the same *Jawa Demam* style as the previous piece, except that it is bulkier and its different decoration is carved in extremely hard ebony. The figure is part-human, but with legs once again ending in a curl, and part-bird, but with a long mustache and flaming semi-spiral eyes. The eight alternating triangles supporting this figure are decorated with a dotted stripe and outspread semi-spiral pattern, similar to the one on the head and body. Once again, several different motifs are compactly carved in a very restricted space.

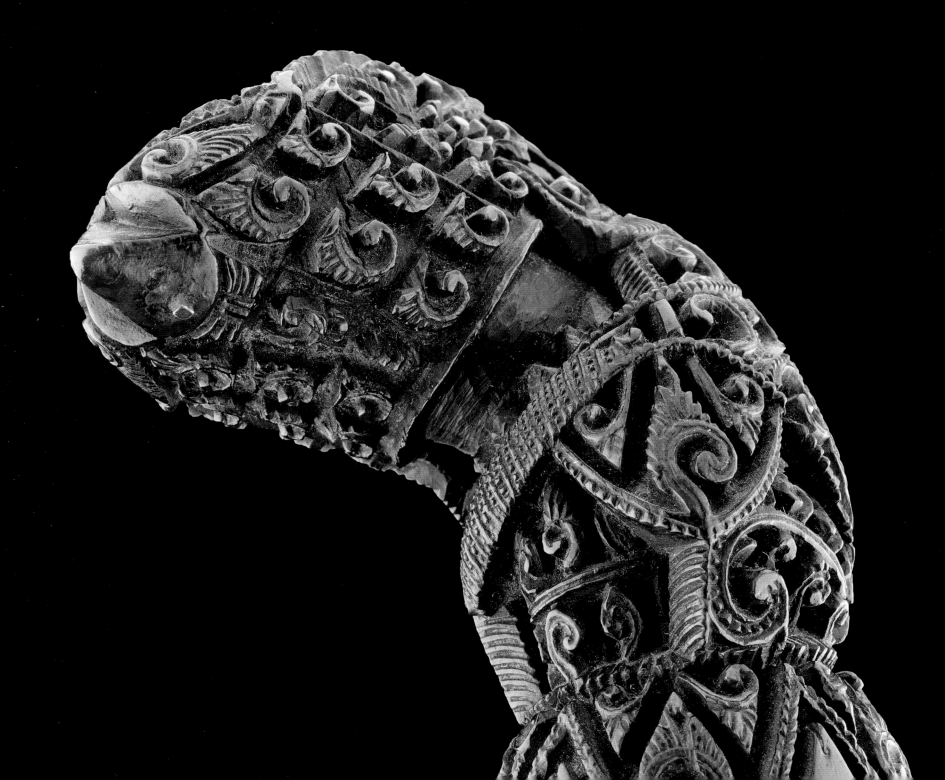

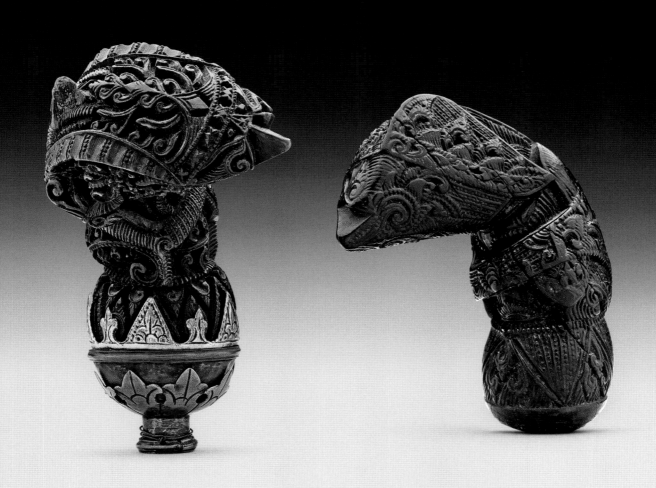

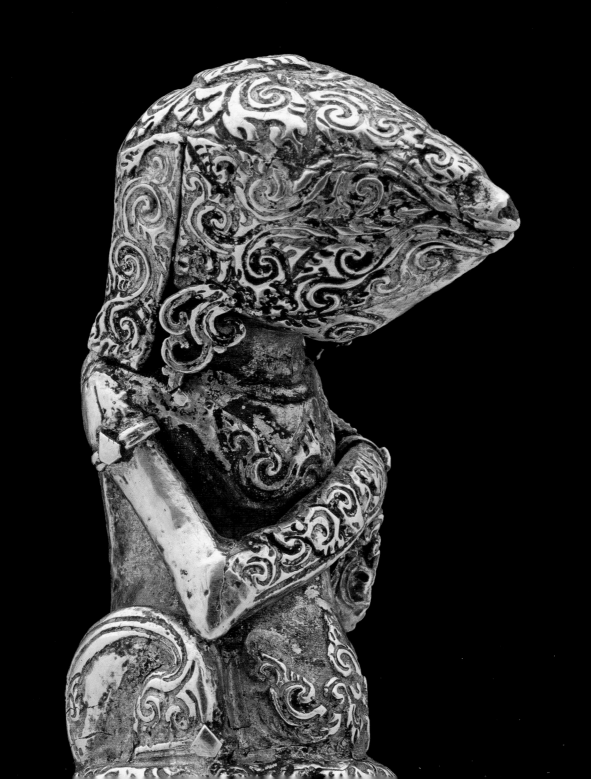

PAGE 111 >

HILT FROM SOUTHERN SUMATRA

Gold

H. 9 cm (incl. base)

This splendid figure in chased gold exhibits the classic scrollwork decoration in the triangles in the base, and spirals for the eyes and mustache. The hair is rendered with an engraved double spiral motif and covers the entire head, sweeping down on either side on two small rectangular plates [page 109, detail]. As usual, the right elbow rests on the knee, supporting the arm as it is reaches across to the left shoulder, the forearm being covered and engraved. The head bears a tendril and spiral decoration and a large, lozenge-shaped flower, while a small crest can be seen on the back of the neck.

A curly leaf emerges from the legs, forming the feet.

The use of gold signifies that the owner of the kris for which this hilt was made must have been a person of substance; indeed, in the past only members of the royal family were allowed to use this precious metal.

PAGES 112-113 >>

HILTS FROM SUMATRA – Palembang

Marine ivory – *Jawa Demam* style

H. from 6.5 to 8.5 cm

This type of hilt is famous throughout Indonesia and Malaysia thanks to two characteristics: firstly, its distinctive shape combining sharp edges, planes and pronounced curves, making these objects particularly attractive, as can be appreciated in the two hilts in the foreground, or the first on the right, where the face, surmounted by a panel with a magnificent floral pattern, is composed of three planes (the eyes with the central jewel) and two triangles (the beak); secondly, the highly elaborate floral and scrollwork pattern alternating with smooth, shiny sections, typical precisely of Palembang. This city was once the capital of the Srivijaya Empire, a Hindu-Buddhist kingdom stretching from Sumatra to the Kra Isthmus in southern Thailand, which flourished from the 7th to the 12th century.

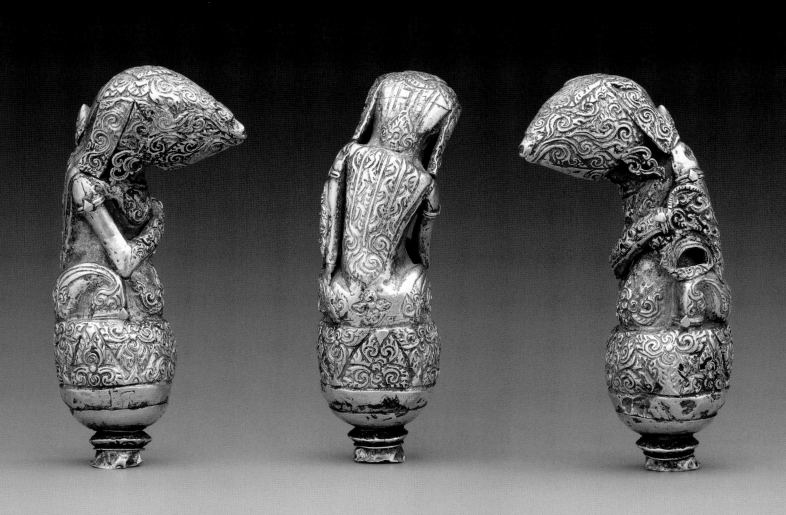

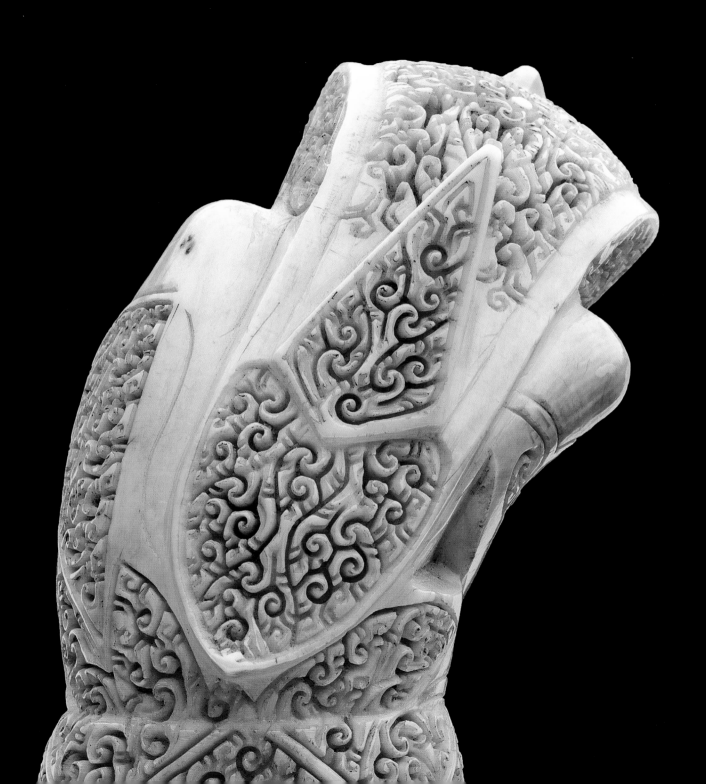

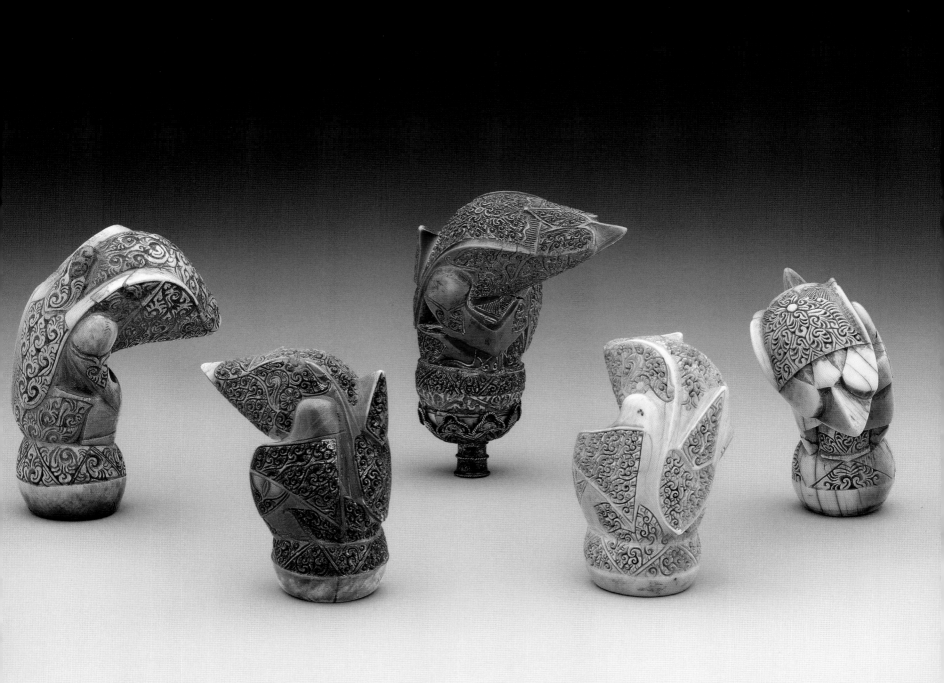

PAGE 115 >
HILTS FROM SOUTHERN SUMATRA – Palembang area

Wood – Marine ivory – *Jawa Demam* style

H. 9.5 cm | H. 9 cm

These *Fevered Javanese* are both seated in the classic squatting position, with the right arm behind the left shoulder to hold the "shawl," which was meant to protect from the cold and fever. But the big bird's head which the two figures seem to find hard to hold up and which not even the dorsal crest and rounded base manage to counterbalance, does it perhaps belong to Garuda, Vishnu's eagle? Only the leaves, starry flowers and the originality of the sublimely carved *tumpal* restore a sense of harmony and distract from the mystery of the origin of the *Jawa Demam*.

PAGES 116-117 >>
HILTS FROM SUMATRA – Minangkabau area

Fossil ivory – Sperm-whale ivory? – Wood – *Jawa Demam* style

H. 11 cm | H. 10 cm, max. width 5 cm, circumference of base 12 cm | H. 10 cm

This fossil ivory hilt [first on the left] once again displays the Jawa Demam style and is 11 cm high, 7 cm at its widest, and has a 13.5 cm circumference at the base—truly extraordinary dimensions. This fossil ivory is very different from the usual elephant molar because it exhibits a variety of shades, the colors ranging from streaks of white, gold and orangey yellow to brown and might be fossil mammoth ivory.

Fossil ivory generally comes from elephant molars and mammoth or walrus tusks, or from the *oosik*, the name given by native Alaskans to the baculum, or penile bone, of the walrus.

The beauty and spirit of this marine ivory [center], whose extraordinary color makes it one of a kind, undoubtedly inspired the craftsman to create this kris hilt, once again in the *Jawa Demam* style typical of Sumatra. He has chosen a material with large patches of bright, light and dark hue, which is ideal to lend the figure a disquieting expression, and he has further embellished it with a finely carved curl and scrollwork decoration on the sides and base. The crest and five-sided panel on the back have an unusual pattern.

This wooden *Jawa Demam* [right] is similar in size to the other two hilts to the left: height 10 cm; maximum width 6 cm; circumference of the base 13 cm. The wood has developed a highly unusual patina, which in some points is opaque and iron grey in color, and in others is reddish and shiny. Once again, the craftsman has skillfully exploited the qualities of the material, the variety in tones and the large eyes typical of the Minangkabau style to produce a highly striking object.

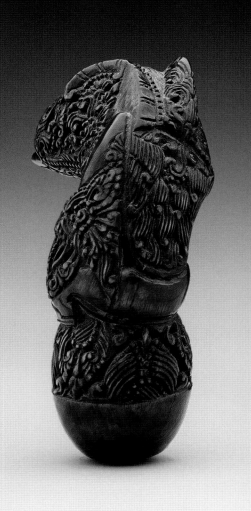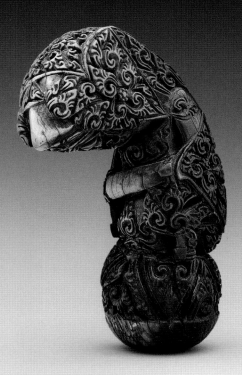

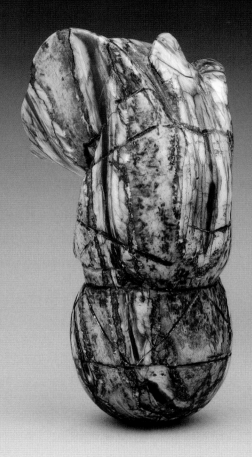
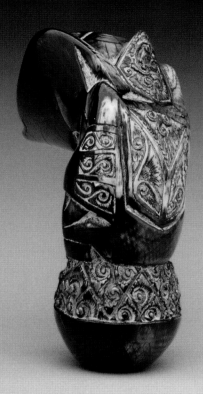
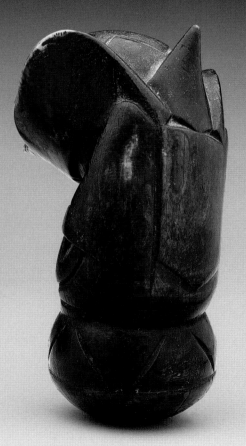

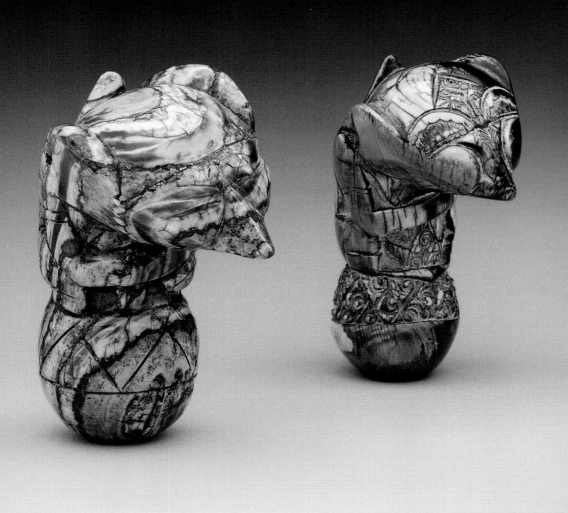

PAGE 119 >
HILTS FROM SUMATRA
Wood – *Jawa Demam* style
H. 7.5 cm | H. 9.5 cm

With its heavy head, semi-spiral eyes, folded legs and concertina feet, fringed flowers to the sides and top of the head, this figure fully reflects the characteristics of this style from the Palembang area, once again illustrating the skills of the Archipelago's master wood-carvers [left].

This hilt made of beautiful reddish wood leans heavily to the right and has spiral eyes, curly hair arranged in a triangular pattern and a large sun (or flower?) on the belly [right]. The crest, top of the head, extremely elaborate "shawl" (or blanket) held in the right hand and the *tumpal* designs at the base, are all decorated with the same carved flower and scroll motifs. As in the hilt on the left and many other similar pieces in this style, the flower on the head has four petals, here made up of semi-scrolls which lend the flower a sense of motion.

PAGES 120-121 >>
HILT FROM LAMPUNG – PALEMBANG – Southern Sumatra
Horn and mother-of-pearl – *Jawa Demam* style
H. 7 cm

The hilts from this part of Sumatra are generally intricately carved and engraved, but this specimen is smooth and plain, as if to prevent the eye from being distracted from the beauty of the material, with its greenish yellow striations embellished by a mother-of-pearl triangle set on the head of this bird figure to symbolize Garuda's beak. Mother-of-pearl is rarely found on hilts, although sometimes *gana*-style hilts are made exclusively of this material. The spiral eyes have two transparent red stones (rubies?) set into them.

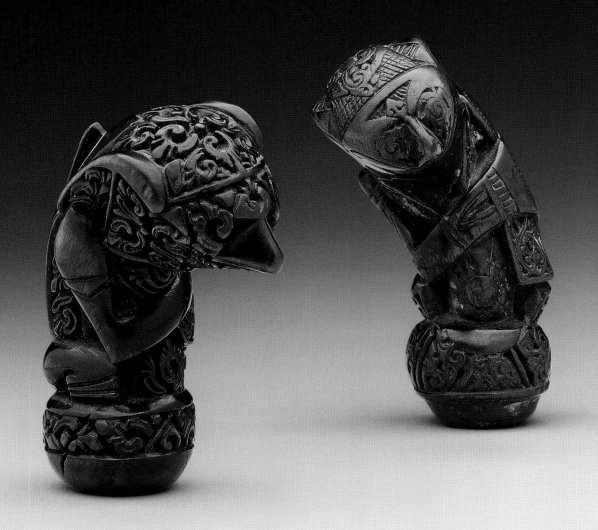

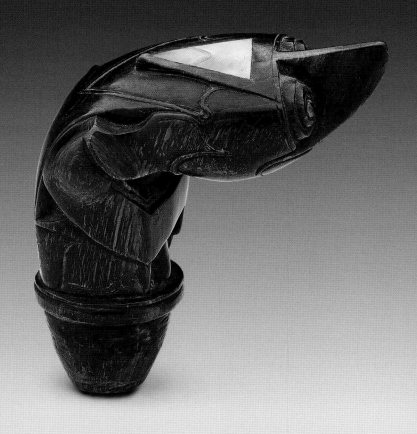

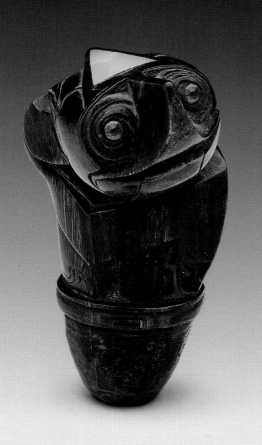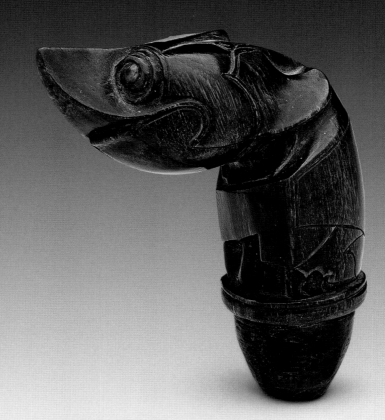

PAGE 123 >
HILT FROM SUMATRA – Minangkabau
Wood – *Jawa Demam* style
H. 10 cm

This large hilt is smooth and unadorned and its large, vacant eyes stare mysteriously into the distance. The crest on the figure's back takes the form of the tip of a six-sided, double-planed panel, probably an extreme stylization of the hair, sweeping down to another point just below the waist. But what makes this specimen so extraordinary is the plasticity of its smoothly rounded proportions, disposed with a masterly sense of balance over a spherical base.

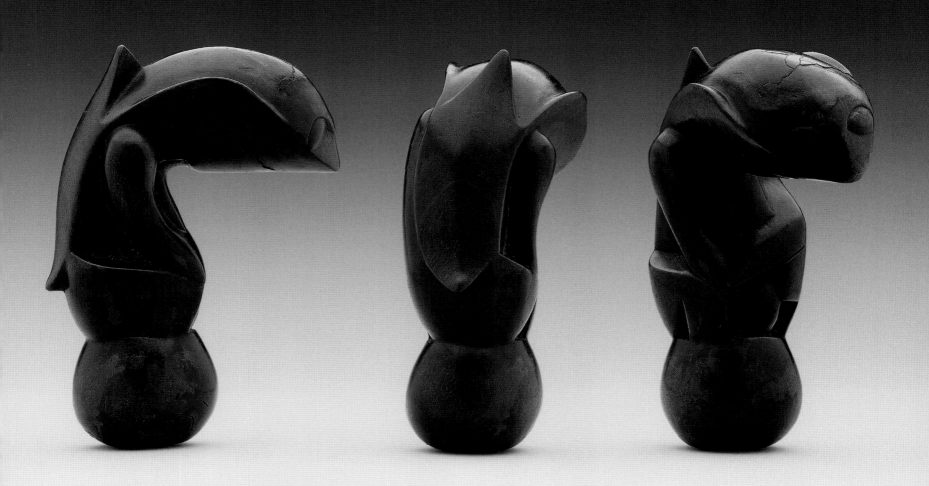

PAGE 125 >

HILTS FROM SUMATRA

Wood – *Jawa Demam* style
H. 7.5 cm

The left-hand hilt [left] is extremely simple, as if intending to stress that what matters is the figure's identity: "I am the ancestor, I am Garuda, I am the Fevered Javanese and my cracks, my splits, my warping tell you all you need to know about my age!"

This figure's eyes [right] are once again picked out with a spiral, but the decoration is geometric rather than floral: triangles, zigzag motifs and straight or undulating lines, with a "shawl" adorned with a tiny check pattern and three diagonal stripes to suggest arms. As if not to deny its own style, the two sides of the body and the crest have the ever-astonishing flaming spirals.

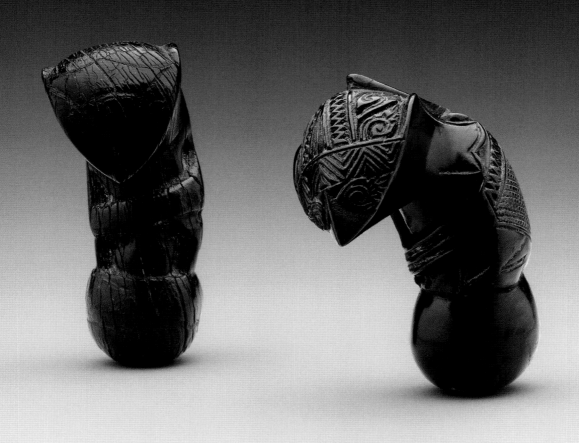

PAGE 127 >
HILT FROM SOUTHERN SUMATRA

Ivory – *Jawa Demam* style

H. 8 cm

In spite of clearly representing a bird's beak, this singular *Jawa Demam* looks like a figure with long, smooth hair combed back. Squatting in the pose of the ancestor, the legs, feet and part of the arm have been turned into vegetation. The right hand, resting on the left shoulder, is also shaped like a leaf and on the neck is carved a large triangular-shaped floral motif, while on the back a beautiful flower rises out of the floral pattern on the base and stands out against the long hair. The *tumpal* motifs are outlined with simple engraved lines. The artist has exploited the play of lines, leaves, triangles and flowers to create a work of great originality.

The ivory used might come from a hippopotamus tooth, which is finer-grained but harder to carve than elephant tusk, and does not darken over time.

PAGES 130-131 >>>
COCKATOO HILT – Malay peninsula

Marine ivory

H. 10 cm (incl. base and crest)

This carving of a cockatoo, the beautiful parrot well known for its eye-catching crest and curved beak, is certainly very different from the aggressive hilts from the northern part of the Malay peninsula. The wings are lightly carved, and the stylization of the feathers and feet is perfect. The crest seems really to be quivering and the light in the two rubies set into the leaf-shaped eyes lends the parrot a cheerful appearance.

It is worth looking at the back of the animal, which reveals how even in the animal kingdom there is potential for experimenting with abstract and geometric patterns. The amber tone of the ivory increases the charm of this hilt set into its *mendak*, the silver element fixing it to the blade.

PAGES 128-129 >>
HILT FROM THE MALAY PENINSULA | BUGI OR SUMATRAN HILT

Giant clam (*Tridacna gigas*) – *Pangulu* style

H. 9.5 cm | H. 7 cm

The size of the giant clam [left] enables even large, heavy objects to be made from it, such as this hilt which weighs 355 grams. This is a Bugi-influenced pistol hilt, but its pronounced crest suggests a Malaysian or Sumatran origin.

This *Pangulu*-style hilt [right] is made of marine ivory. "*Pangulu*" is an Indonesian word whose correct spelling is "*Penghulu*", meaning "village headman", or "Moslem leader". This specimen might also come from Malaysia or even Sumatra, as the Bugi have had a considerable political and artistic influence over these two areas.

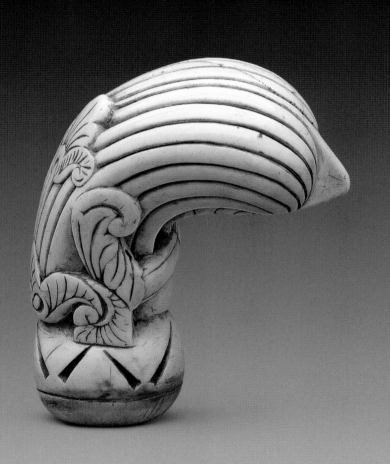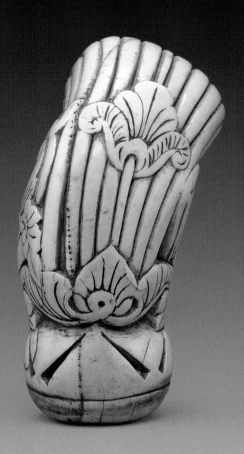

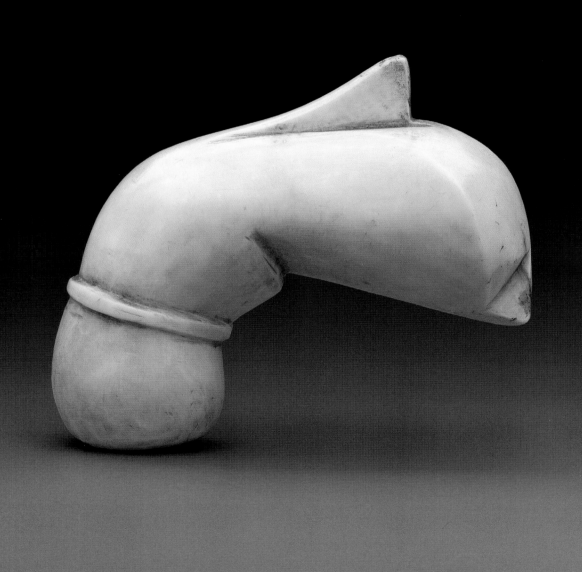

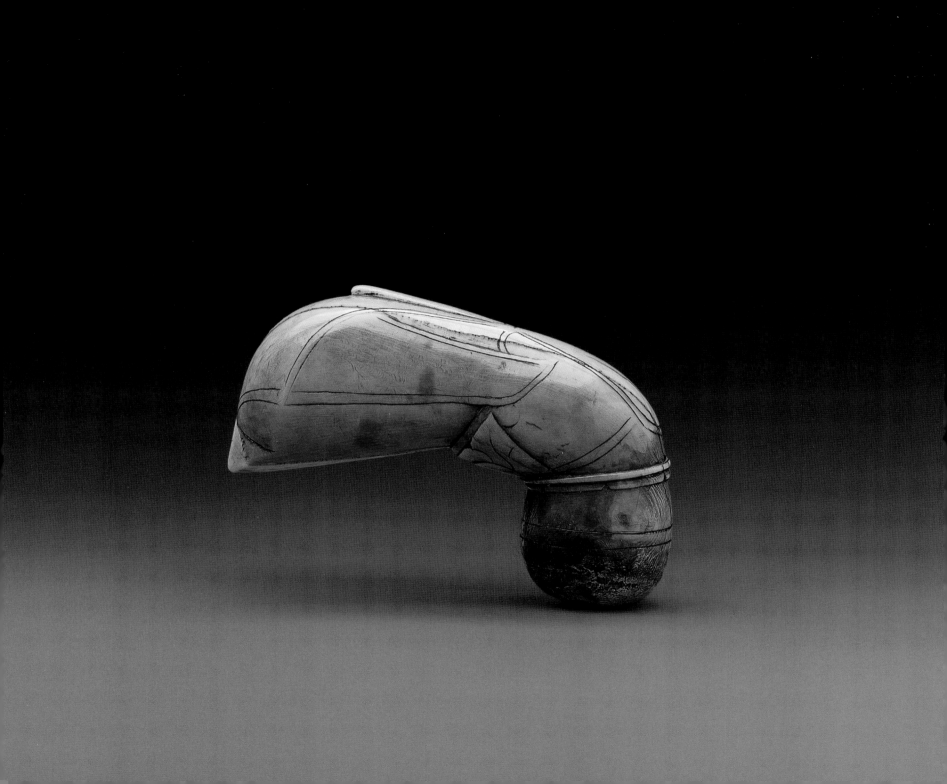

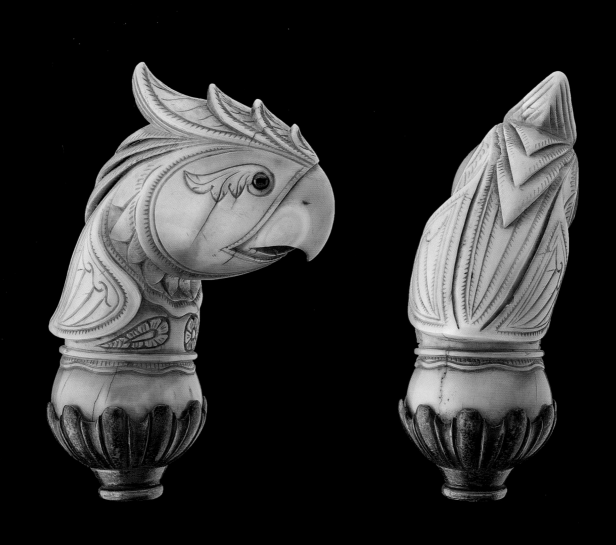

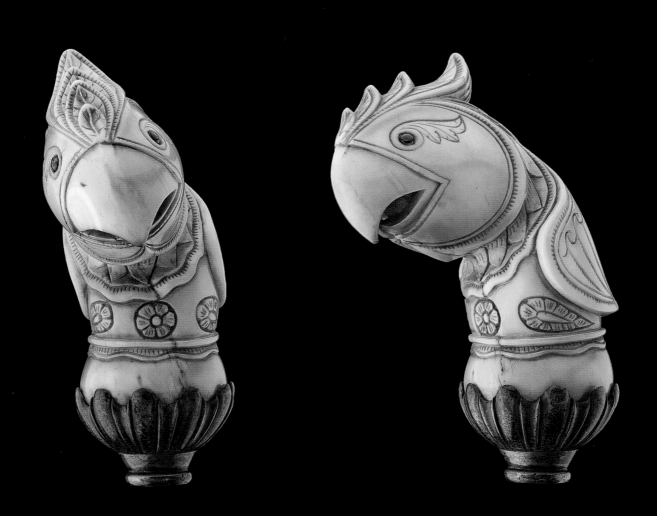

HILT FROM SUMATRA
Wood – *Jawa Demam* style
H. 4.5 cm

This invaluable and extremely rare hilt is carved in the grand style of Sumatra, an island known in ancient times by its Sanskrit name of Svarnadvipa, or Svarnabhumi, Isle, or Land of Gold, on account of its gold deposits. This hilt is very small, only 4.5 cm high, and belonged to a woman's kris, which was easy to hide but could be quickly drawn.

While the *patrem*-type of woman's kris from Java was slipped among the folds of the upper band of cloth, *stagen*, around the waist, there also existed tiny kris which could even be hidden in a coil of the woman's hair.

HILTS FROM LAMPUNG – southern Sumatra
Wood – Rhinoceros horn – *Hulu Burung* style, bird hilt
H. 9 to 10 cm

With their human arms, legs and feet, these long-beaked birds with a tropical crest do not look as though they are about to fly. They are squatting on a *tumpal* throne in the typical ancestor pose, except for one that appears to emerge from an open or upturned flower (picture with a single specimen). Long curls sweep down the figure's back and the large eyes have a distracted expression. The tones of the different types of wood and rhinoceros horn (first on the left, in the foreground, multiple image), the variety of engraved patterns, such as the traditional square spiral motif (picture with a single specimen), the triangular palmettes, the feathers depicted as tight curls, the whirling flower, or sun, and many others are unrivaled.

Perhaps these birds represent a disguised version of Garuda, an interpretation corroborated by the two fearful and extremely long fingernails.

As regards the various types of "bird/ancestor" hilts found in the Malay Archipelago, it is worth considering an extremely interesting parallel which has been entirely overlooked: among the Micronesian inhabitants of Oceania, where ancestor worship plays an important part in social life, deified ancestors are venerated in the form of birds.

This type of bird hilt, with a long beak, is sometimes thought to originate in Riao province and the islands of the same name lying off the eastern coast of Sumatra and south of Singapore.

In the multiple image [page 137] the beak of the first hilt on the right is slightly upturned, making it different from the others. It may be a Coteng hilt from Songkhla (southern Thailand) once the seat of an ancient Malay kingdom called Singgora. It is made of Kenaung wood (*Dyospiros ebenum*, a type of ebony native to southern Thailand) and it is a mix of the *Coteng* and the *Jawa Demam* style.

This type of hilt dates from the 18th century. It is found further north than the hilts typical of the Tajong kris and still displays the features that have disappeared from the latter—a flat head extended in length by the Garuda beak, long nose, although unlike the kind from Lampung, and well-defined arms and legs. This is a rather rare and little-known kind of hilt, owing to the circumscribed zone of production, and the fact that the area passed under Thai sovereignty in the 18th century.

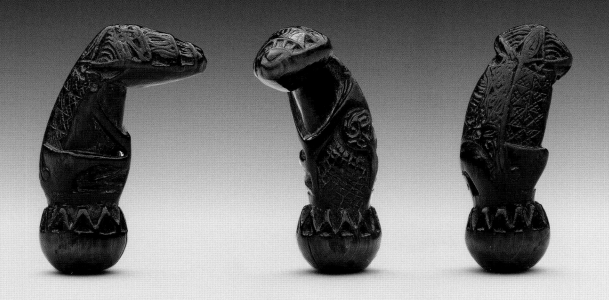

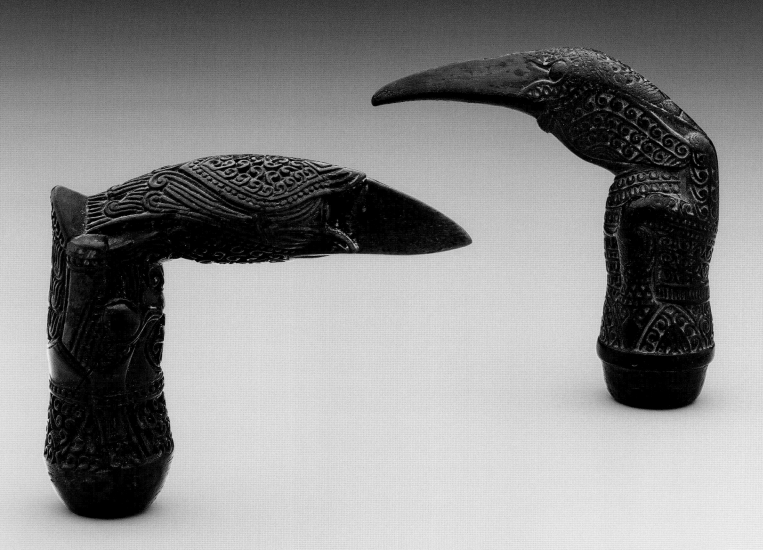

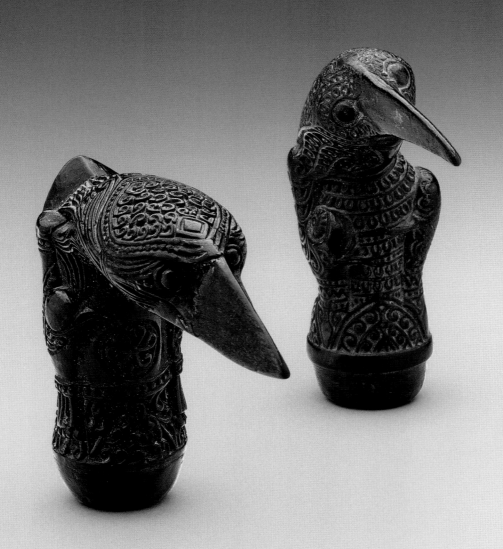

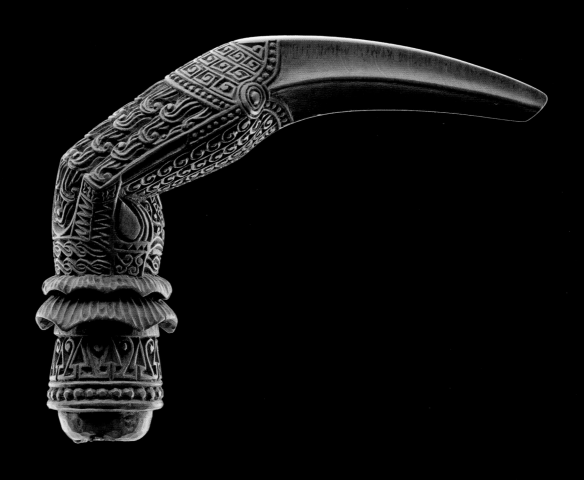

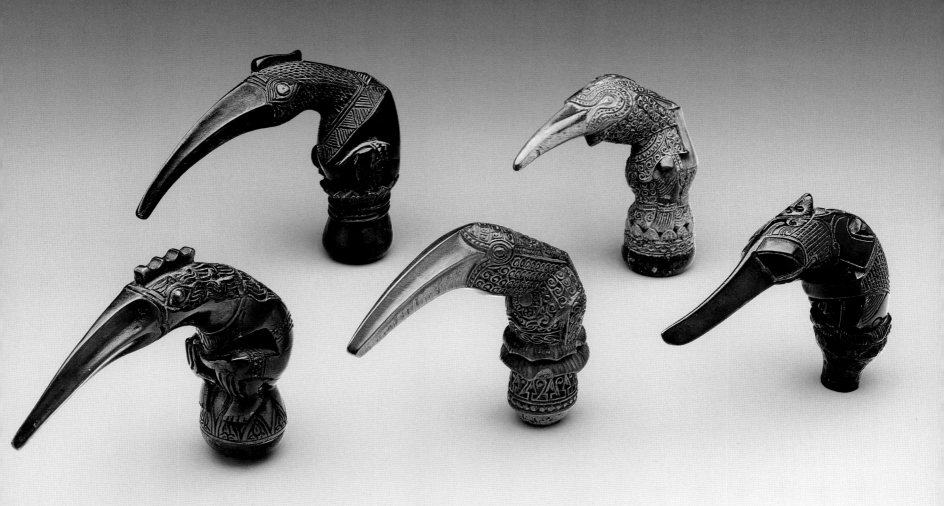

PAGE 139 >
HILT FROM CENTRAL SUMATRA | HILT FROM SOUTHERN SUMATRA – Lampung
HILT FROM SUMATRA – Lampung?
Wood – *Jawa Demam* style | Ebony | Wood
H. 7 cm | H. 8 cm | H. 8.4 cm

Sumatran artist-craftsmen do not do things by halves when it comes to creating a *Jawa Demam*. Once again, this example [left] has been decorated with three different motifs: a floral pattern on the sides and head, a vertical and diagonal geometric design at the front and wavy lines on the *tumpal* and behind to indicate curls.

This bird-man seated on *tumpal* motifs is rather unusual [center]. He wears an elaborate, three-layered hairstyle and holds a round object in his hand, while a large necklace covers the whole of his chest, and his feet poke out from under the band marking the base of the throne, exactly as if the ankles were bound up by this very belt. Anything is possible in the fantastic world of the kris… unless this is a meditation belt! It is worth remarking on the engraved curls indicating feathers, and the match between the side *tumpal* on the base and the triangle formed by the arm-necklace.

Perhaps this particular *Jawa Demam* comes from Lampung [right]. While retaining the features of the area and the curl-spiral decoration, it is unusual in having a fierce expression, a beard and an extremely pronounced Garuda beak between the shoulders and the curly hair. Here one can see how "contaminated" the Fevered Javanese is: half-man, half-bird, but seated like an ancestor, and with an ascetic's curly hair, the figure perhaps represents Garuda, except that Garuda's beak is on his back. The piece is from Sumatra, but perhaps comes from Java. This is definitely a mysterious figure and the object of considerable study by experts in kris hilts.

PAGES 140-143 >>>
HILTS FROM WESTERN JAVA – Cirebon
Wood – marine ivory – horn
H. 8–9 cm

Weathered and worn ancient ivory and wood are the two endearing features of these hilts, which perhaps represent the ancestor or Bhima, the much-loved hero of the Mahabharata, who in turn symbolizes the ancestor. The hands rest on the legs, displaying two extremely long thumbnails, which immediately suggest the figure could be Bhima. Others have identified the figure as Garuda because, as in the first three hilts on the left and in the second from the right, he wears a fearful necklace made of snakes, calling to mind the divine eagle, the conqueror of snakes in Indian mythology, who holds a serpent to his neck as a symbol of his victory and also has very long thumbnails (although Bhima also sometimes wears a snake necklace). The three hilts on the left all wear a crown on their head, denoting great nobility. The others are similar to those described, with the difference that they wear elaborate necklaces. All eight figures have extremely long, curly hair, indicating their ascetic virtues. Looking closely at these hilts one suddenly feels transported into an alien dimension with a sense almost of unease and a subtle, unaccountable fear.

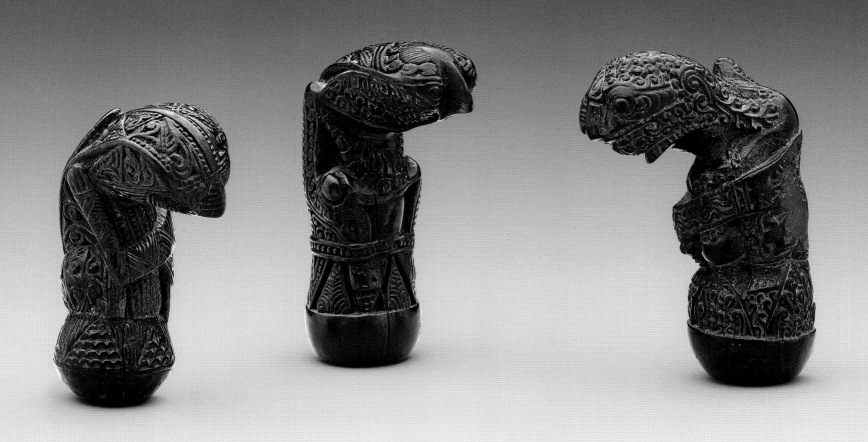

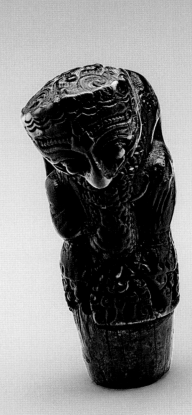
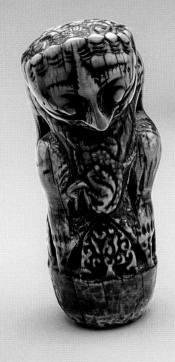
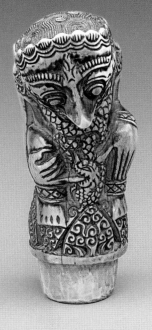
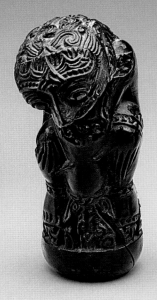

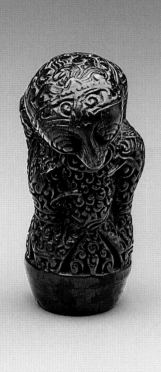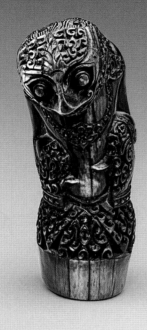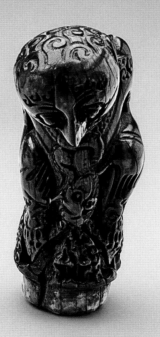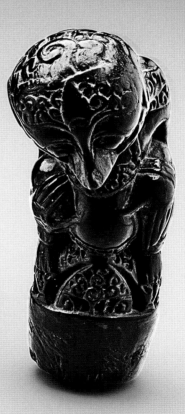

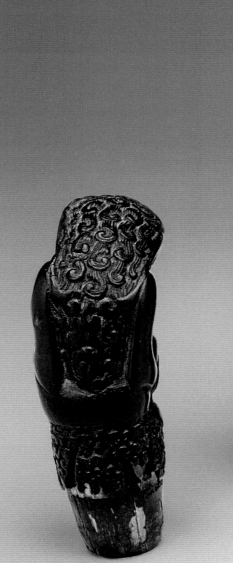
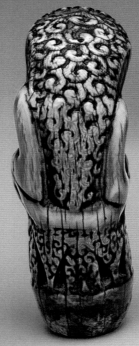
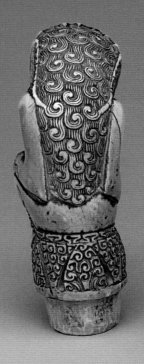
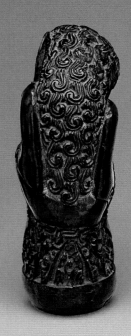

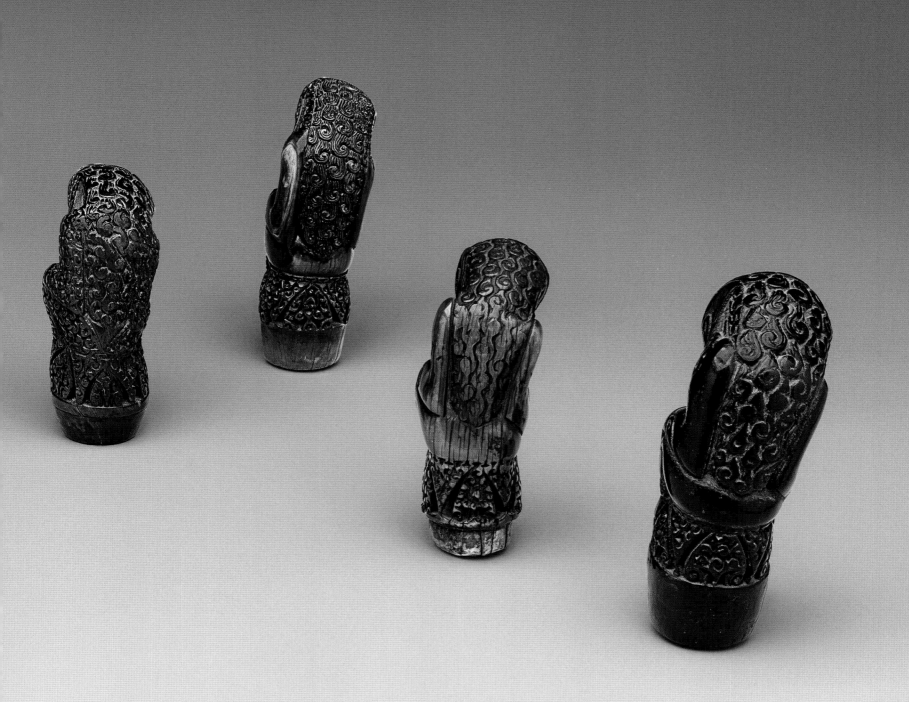

PAGE 145 >
HILT FROM A WOMAN'S(?) KRIS-Java(?)
Iron
H. 5.8 cm

This is an extremely interesting iron hilt, since it might belong to a woman's kris. But look-
ing at the base, one wonders how the blade could have been mounted. It might be that
an element below has been lost, or that another small base was added to hold the tang
of the blade, as occurred in some cases. The figure has bulbous eyes and a prominent
nose, a highly elaborate hairstyle with a large chignon-curl, and holds two buds in its
right hand and a fowl, possibly for a sacrifice, in the left. The figure is seated on a throne
with a double triangle on the front and back, with the two on the front being smooth,
while the larger one on the back has a flame-like appearance and the smaller seems to
contain the "burning eye of the sun".

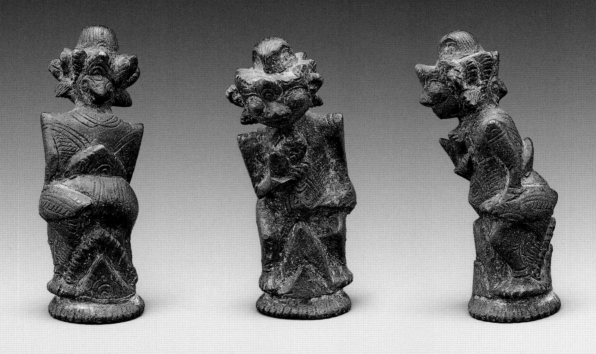

PAGE 147 >
HILT FROM WESTERN JAVA – Banten
Copper alloy
H. 7.7 cm

This hilt from Banten perhaps depicts a demon or a *yaksha*, a minor deity living in the forests and on trees who is sometimes benevolent and sometimes malign, as might be deduced from the hands ending in leaves. The figure is seated naked on a floral base with the classic C-shaped ornament, its long hair sweeping down its back to indicate its ascetic nature, a luxuriant mustache and spiral eyes. The stylized penis probably includes a *palang*, a small piece of wood with two little balls at the end which was inserted under the head of the penis. The "burning eye of the sun" appears on the base, both on the front and the back. Copper is a material that is rarely used in hilts.

PAGES 148-149 >>
HILT FROM BALI/LOMBOK
Silver – *Gerantim* style
H. 11 cm

Hilts of this type were designed for kris worn by nobles and kings and were even made of gold and precious stones. Aside from the material used, their distinction lies in the intricately woven silver thread forming little two-toned checks. This extremely precise process took considerable skill and time. The weave is also important in establishing the age and authenticity of the piece, since this pattern is printed on in modern times. A lotus flower has been engraved on the top of the hilt, from the center of which rises a long spiraling stalk. It is this type of detail that suggests this specimen comes from the island of Lombok. Eight small silver balls at the base imitate the cabochon gems that are commonly found in hilts from the two islands.

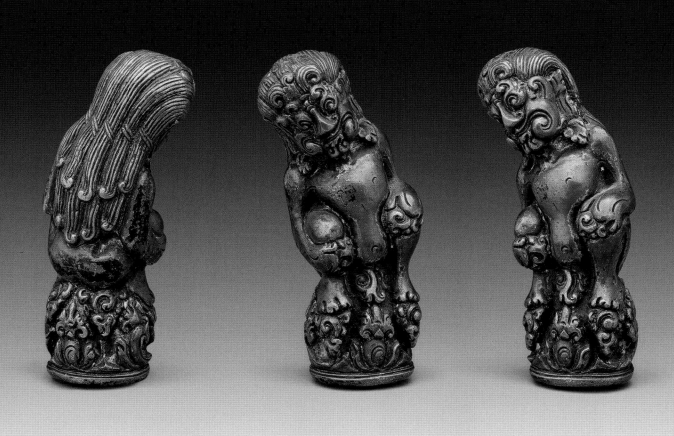

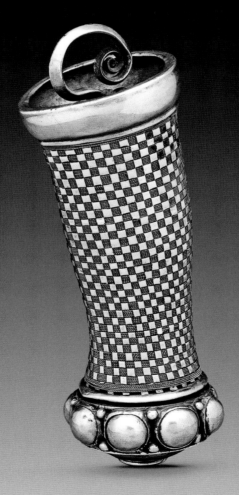

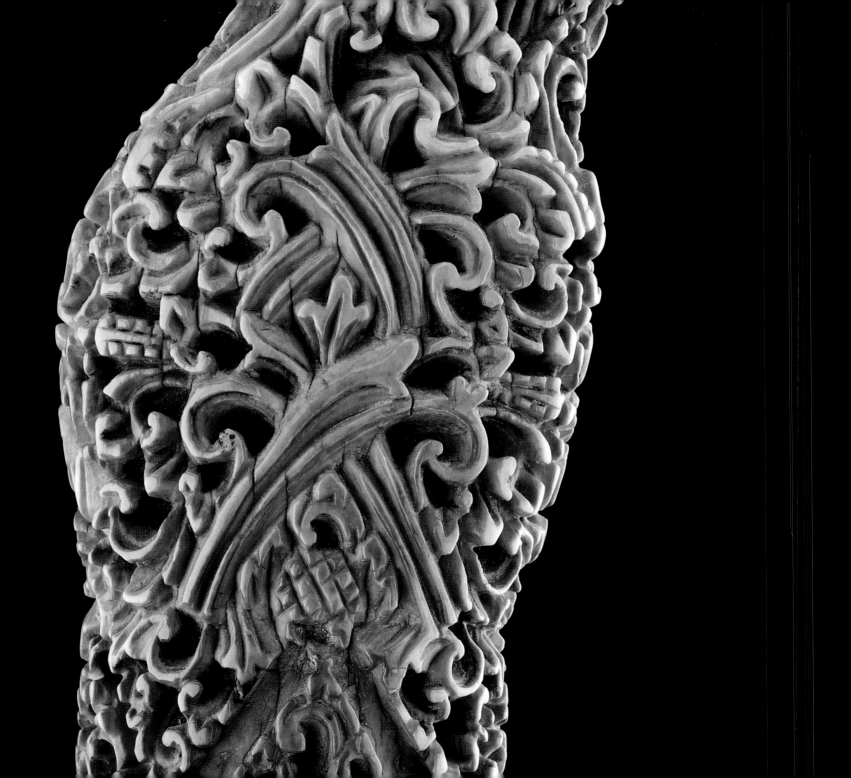

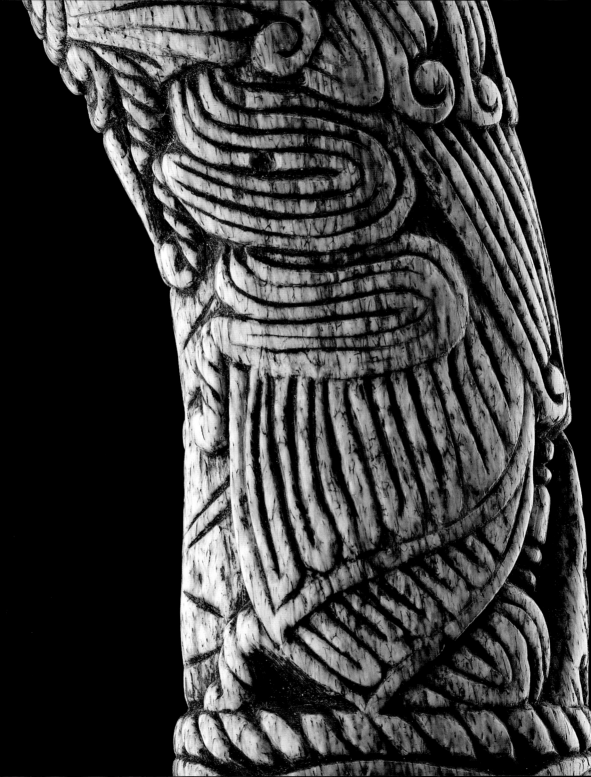

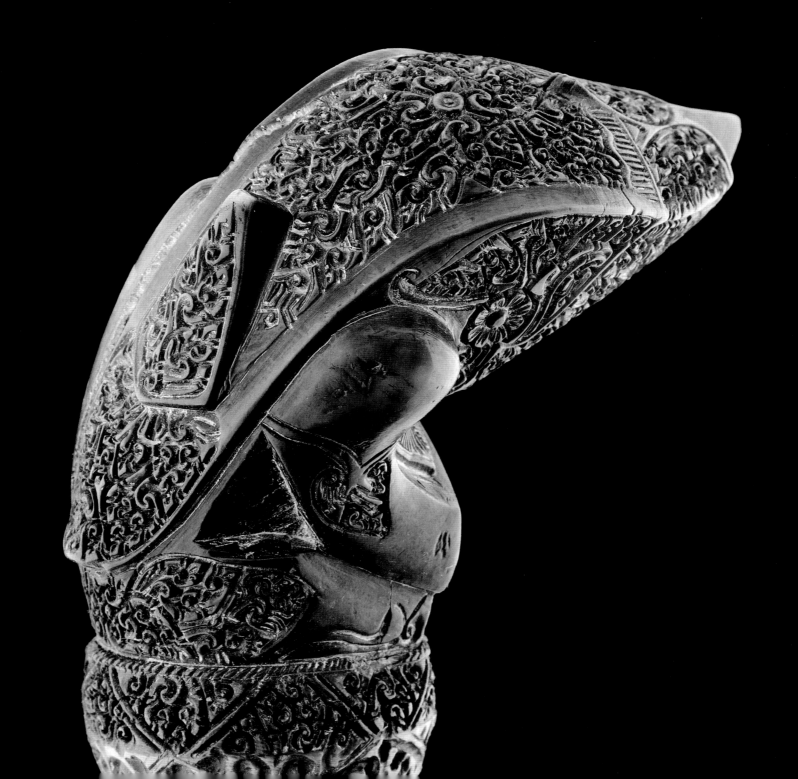

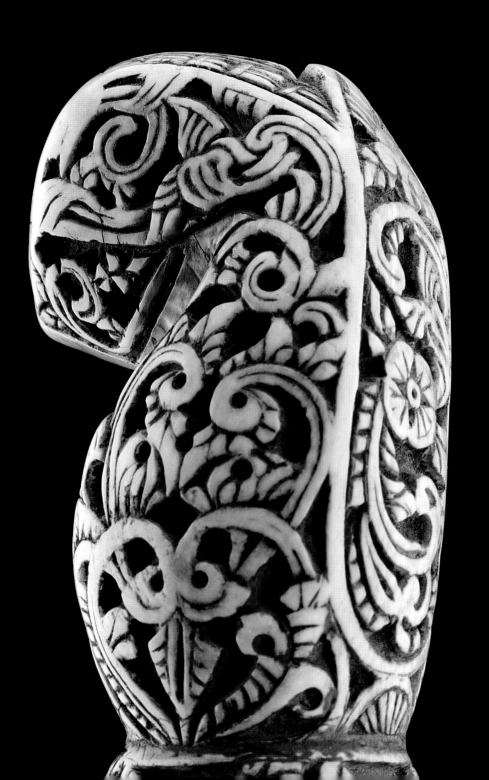

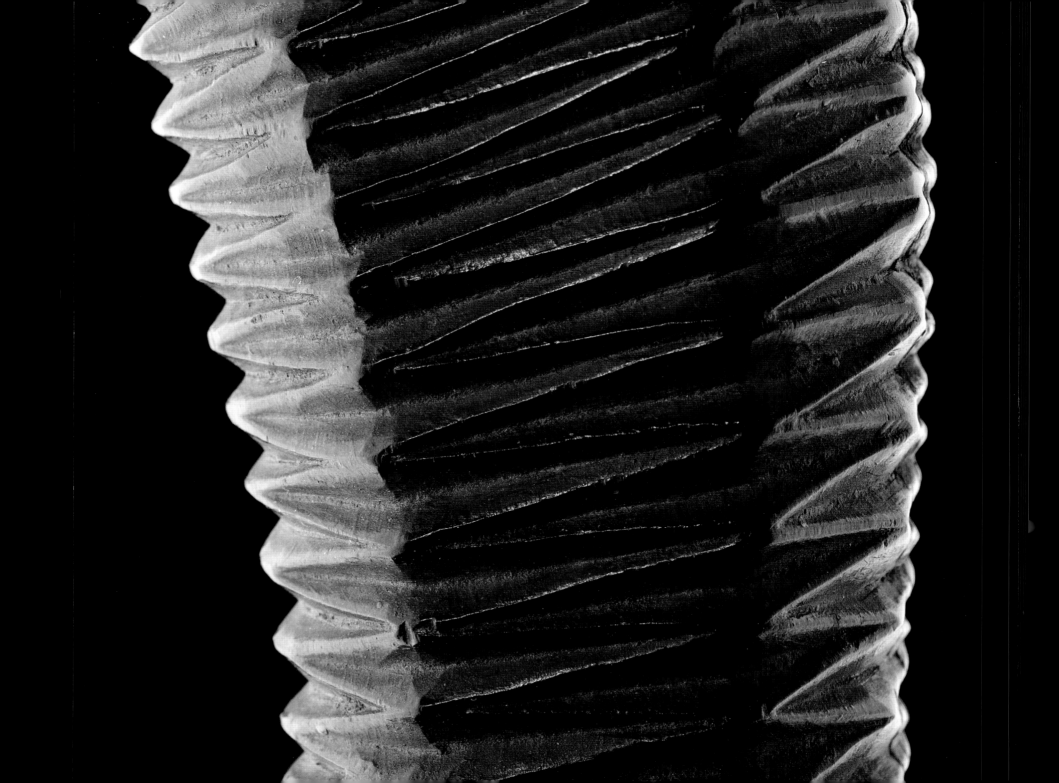

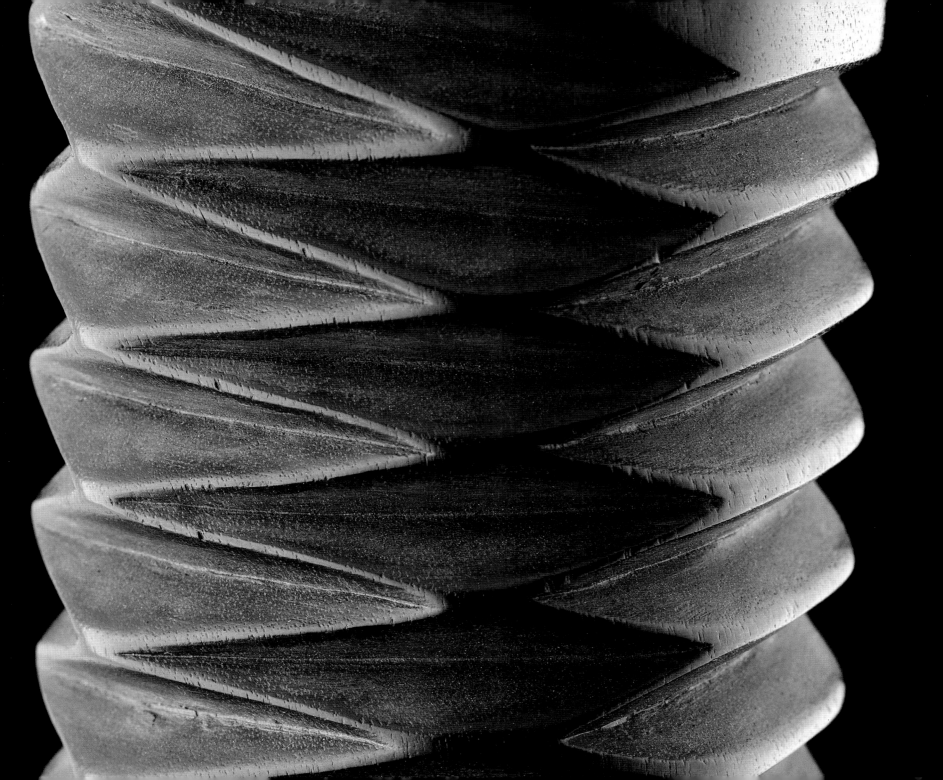

BIBLIOGRAPHY

Alkema, T. (ed.), B. Grishaaver, and K. Sirag. *Iron Ancestors. Kris Sajen, Kris Majapahit and Related Objects*. Leiden: C.Zwartenkot Art Books, 2010.

Alte Kulturen auf Sumatra, Java, Borneo. Exhib. cat., Staatlichen Museums für Völkerkunde, Dresden 1985–86.

Arts of Asia (Sept.-Oct. 1992, March-April 2006 issue).

Budaya Indonesia, Arts and Crafts in Indonesia. Exhib. cat., Tropen Museum, Amsterdam, 1987.

Budiarti, Hari. "Kris and Other Indonesian Traditional Weapons." *Arts of Asia* (Sept.-Oct. 2003).

Dibia, IB. *Keris Bali (Balinese Keris)*. Bali: C.V. Indopres Utama & Co., 1995.

Duuren, D. van. *The Kris—An Earthly Approach to a Cosmic Symbol*. Wijk en Aalburg: Pictures Publishers, 1998.

———. *Krisses—A Critical Bibliography*. Wijk en Aalburg: Pictures Publishers, 2002.

Engel, J. *Krisgrepen, Samurai Wapenhandel*.

Amsterdam: Samurai Wapenhandedl, 1990.

Frey, E. *The Kris—Mystic Weapon of the Malay World*. Oxford and New York: Oxford University Press, 1988.

Gardener, G.B. *Keris and other Malay Weapons*. Wakefield: EP Publishing Limited, 1973. (1st ed., Singapore 1936).

Ghiringhelli, V. "Keris Hilts Materials." *Arts of Asia* (Sept.-Oct. 1997).

———. "Il tempo sacro dell'armaiolo giavanese" ("Saat keramat bagi pembuat keris bangsa Jawa," Indonesian translation by Lily Soerjowati). *A Oriente, Il Tempo in Oriente* 7, III (2002): 36–40.

———. *The Invincible Krises 2*. Vercelli: Edizioni Saviolo, 2007

Ghiringhelli, V. and M. *The Invincibile Krises*. Milan: BE-MA Editrice, 1991.

Greffioz, J. The Kris. *A Passion from Indonesia*. Chambourcy: 2008

———. Kris Hilts. *Small Masterpieces from Indonesia*. Chambourcy: 2009

Greve, R. *Keris*. Rijsenburg: Uitgeverij Zevenster, 1992.

Groneman, I. *The Javanese Kris* (preface and introduction by David van Duuren). Leiden: C. Zwartenkot Art Books and KITLV Press, 2009.

Hamzuri, Drs. *Keris*. Jakarta: Penerbit Djambatan, 1988.

Hill, A.H. "The Kris and Other Malay Weapons." *Journal of the Malayan Branch of The Royal Asiatic Society* 176/4, XXIX (1956).

Java und Bali. Exhib. cat., Linden-Museum Stuttgart, 1980. Mainz am Rhein: Verlag Philipp von Zabern, 1980.

Jensen, S. K. *Den Indonesiske Kris—et symbolladet våben*. Naestved: Devantier, 1998.

Jensen, S.K. *Krisdisk. Krisses from Indonesia, Malaysia and the Philippines*. Copenhagen: 2007

Jessup Ibbitson, H. *Court Arts of Indonesia*. New York: The Asia Society Galleries & Harry N. Abrams, 1990.

Kamstra, E. "Een greep uit de collectie. Een

verzameling Indonesische Krisheften." *Aziatiske Kunst* 3 (Jaargang 32, Sept. 2002).

Kerner, M. *The Keris in the Magic World-View*, Kirchdorf: 1999.

———. *Keris-Griffe aus dem Malayischen Archipel*. Exhib. cat., Museum Rietberg, Zurich, 1996.

———. *Statistik der Frühen Kerise*. Kirchdorf: 1997.

Kerner, M. *Keris Griffe aus Museen und Privatsammlungen*. Kirchdorf: 2000.

Keurs, P., and Sri Hardiati. *The Discovery of the Past*. Exhib. cat, Jakarta and Amsterdam: Endang Editors, 2005.

Le Dauphin, C. "Les Poignées de Kriss." *Kaos, Parcour des Mondes* 1 (Sept. 2002).

Moerbiman. *Keris and Other Weapons in Indonesia*. Jakarta: Yayasan Pelita Wisata, 1973.

Noor, F.A., and F.E. Khoo. *The Spirit of Wood. The Art of Malay Woodcarving*. Hong Kong: Periplus Editions, 2003.

Skeat, W.W. *Malay Magic*. London: Frank Cass & Co., 1965 (1st ed. 1900).

Solyom, G., and B. Solyom. *The World of the Javanese Keris*. Honolulu: East-West Center, 1978.

Spielmann, W. "Der javanische Keris, Funktion und sozio-religiöse Symbolik." *Mundus Reihe Ethnologie,* 41 (1991).

Tammens, G.J.F.J. *De Kris—Magic Relic of Old Indonesia*, vol. 1. Eelderwolde: 1991.

———. *De Kris—Magic Relic of Old Indonesia*, vol. 2. Eelderwolde: 2001 (1st ed. 1993).

———. *De Kris—Magic Relic of Old Indonesia*, vol. 3. Eelderwolde: 1994.

Veenendaal van, E.A.N. *Krisgrepen En Scheden Uit Bali En Lombok*. Bunnik: 2009

Wassing-Visser, R. *Royal Gifts from Indonesia*. Zwolle: House of Orange-Nassau Historic Collection Trust. The Hague: Waanders Publishers, 1995.

Wolley, G.C. "The Malay Keris: its Origin and Development." *Journal of the Malayan Branch of the Royal Asiatic Society* II, vol. XX (Dec. 1947).

Zonneveld, A.G. van. *Traditional Weapons of Indonesian Archipelago*. Leiden: Zwartenkot Art Books, 2001.

THE AUTHORS

Vanna Scolari Ghiringhelli is a collector and expert in Eastern side-arms, and since 1968 she has specialized in krisses and kris hilts. A member of the Accademia Ambrosiana, she is an associate of the Italian Institute for Africa and the Orient, and Vice-President of the Italian-Asian Cultural Center in Milan. She has taught Hindi at the Università degli Studi in Milan.

Mauro Magliani is an Italian fine art photographer and has worked with the assistance of his wife Barbara Piovan on numerous books dedicated to important art collections.

ACKNOWLEDGMENTS

Lele Lanfranchi would like to thank
Cicci Berger
Bruce Frank
Renzo Freschi
Roberto Gamba
Colette Ghysels
Serge Le Guennan
Davide Manfredi
Pietro Notarianni
Alexandra Pascassio
Jack Sadovnic
Alain Schoffel
Maureen Zarember

The author, Vanna Ghiringhelli, is most grateful to Sandro Forgiarini, Jean Greffioz,
Emile van Veenendaal for their invaluable help.

Colour Separation
Pixel Studio, Milan, Italy

Printed and bound in Italy in August 2011
by Grafiche Flaminia, Foligno (PG)
for 5 Continents Editions, Milan